TRANSPARENT PAINTING TECHNIQUES

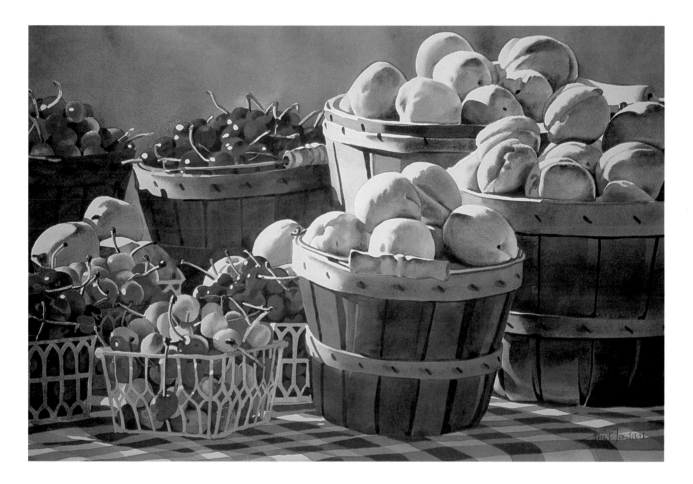

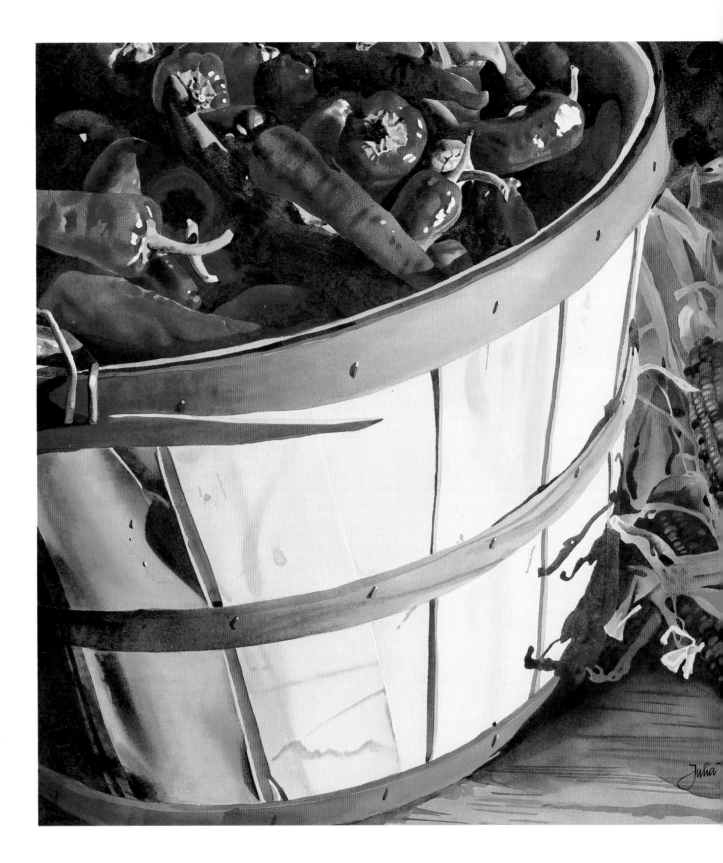

TRANSPARENT PAINTING TECHNIQUES

How to Achieve Veils of Luminous Color in Watercolor and Acrylic

JULIA JORDAN

WATSON-GUPTILL PUBLICATIONS/NEW YORK

To Monte, who pays attention.
To Mimi, who keeps on growing.
To Dirk, who is an old soul.

Art on first page:
Summer Fruits by Julia Jordan. Transparent
acrylic on d'Arches 140 lb. cold-pressed paper,
15 × 22" (38 × 56 cm). Collection of Harold and Carol Evans.

Art on title page:
Chiles and Corn by Julia Jordan. Transparent
acrylic on d'Arches 140 lb. cold-pressed paper,
22 × 30" (56 × 76 cm). Collection of Glen and Sandi Jordan.

Edited by Candace Raney and Janet Frick
Designed by Areta Buk
Graphic production by Ellen Greene
Text set in 9.5 pt. Palatino

Copyright © 1992 Julia Jordan

First published in 1992 in the United States by
Watson-Guptill Publications, a division of
BPI Communications, Inc., 1515 Broadway, New York, N.Y. 10036.

Library of Congress Cataloging-in-Publication Data
Jordan, Julia.
 Transparent painting techniques : how to achieve veils of luminous
 color in watercolor and acrylic / Julia Jordan.
 p. cm.
 Includes index.
 ISBN 0-8230-5435-7
 1. Transparent watercolor painting—Technique. 2. Acrylic
 painting—Technique. I. Title.
 ND2430.J68 1992
 751.42'2—dc20 91-37391
 CIP

Distributed in Europe, the Far East, Southeast and Central Asia, and South
America by RotoVision S.A., 9 Route Suisse, CH-1295 Mies, Switzerland.

Manufactured in Singapore

First printing, 1992

2 3 4 5 6 7 8 9 10 / 96 95 94 93 92

ACKNOWLEDGMENTS

My first and greatest thanks go to my husband, Monte Jordan, who cared about the book at least as much as I did, and kept me from getting discouraged when minor obstacles arose. Without the help of James Hart, master photographer, the book might never have been finished. The perfect photographs in this book should be credited to him; any that are imperfect are mine. Juergen Haber introduced me to the computer and guided me in my fledgling efforts to master its use for writing this book; many thanks to him as well.

I also appreciate the contributions of several people at Watson-Guptill. Senior editor Candace Raney helped bring this book to life by guiding me as I developed it from an idea to a complete manuscript. Designer Areta Buk wove all the visual pieces into an esthetic whole. Production manager Ellen Greene carefully checked the color reproduction of all the illustrations and kept them as faithful as possible to the original paintings. Finally, associate editor Janet Frick contributed greatly to the clarity and consistency of the text and pictures with her penetrating intelligence and persistent probing; I am grateful for her help.

Now if these words are helpful for you,
then put them into practice.
But if they aren't helpful,
then there's no need for them.

—The Dalai Lama, *Ocean of Wisdom*

CONTENTS

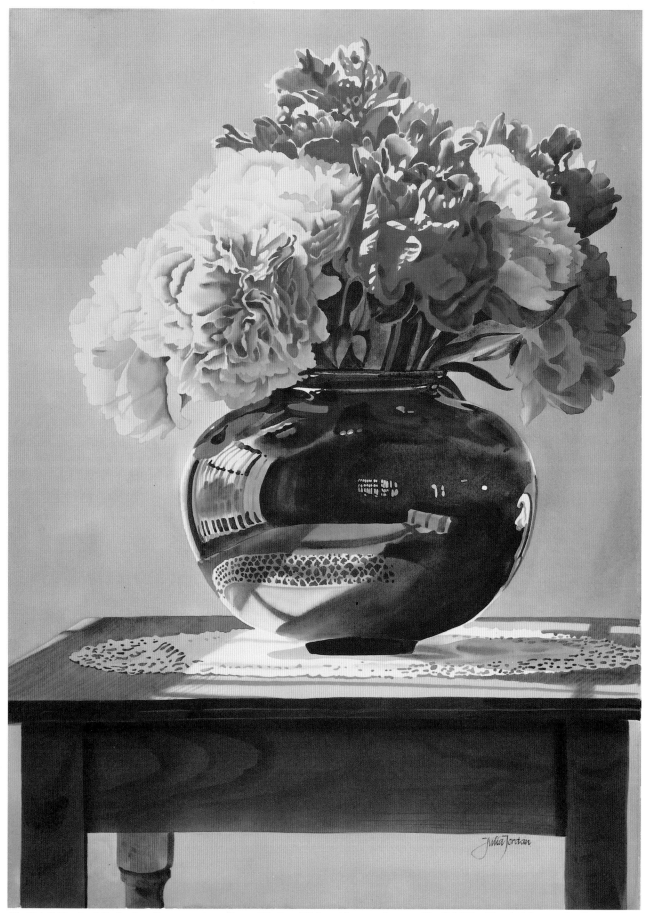

The Cobalt Vase by Julia Jordan. Transparent acrylic on d'Arches 140 lb. cold-pressed paper, 30 × 22" (76 × 56 cm). Private collection.

INTRODUCTION: ALL'S FAIR IN ART

The well-known cliche "All's fair in love and war," upon reflection, has dubious validity. But art! Especially in a society blessed with the First Amendment and the past fifty anarchic years of art history, anything goes.

For that reason, this book will have little to say about the content of painting, or rules of composition, or what colors "go together." When it comes to making art, you *have* to do whatever you want. The purpose of this book is to help you get the results you want in the easiest, least frustrating manner. And if it's true that "all's fair in art," any means to get the result you want are legitimate. The only laws that apply are the laws of physics.

This book is aimed at the painter who delights in transparency—the glowing effect that results from applying paint in thin washes and allowing the white of the paper to replace the use of white pigment. Two water media, watercolor and acrylic, will be discussed; these are *the* transparent water media. Other water media, such as casein, gouache, tempera, and acrylic-plus-white-paint, will not be covered because their inherent opacity is ill suited to transparent techniques.

My own fascination with transparent painting began with explorations in traditional watercolor, and much of what I know about watercolor I learned from books like this one. Over the years I took several workshops with well-known water media painters who contributed to my cache of technical painting knowledge. Then I began to synthesize these educational sources with my own practical painting experience, and in my search for solutions to some vexing technical difficulties inherent in watercolor, I tried painting transparently with acrylic.

Generally, books and workshops that teach the use of acrylic as a water medium concentrate on its *opaque* incarnation; that is, acrylic including white pigment. Since opacity did not interest me much, it took me a long time to notice the advantages of acrylic for transparent painting. A second reason I was put off by acrylic was the rather greasy sheen imparted by gloss acrylic medium, which interfered with the matte surface I appreciate in watercolor. Then I discovered matte acrylic pigments and medium.

Finally, conventional wisdom has it that acrylics inevitably ruin your brushes, so cheap synthetics are recommended by instructors in the belief that these will be easier to replace when they become too stiff to use. Hooked as I am on the virtues of expensive sable brushes, restriction to the relatively clumsy synthetics seemed rather like taking a shower with my clothes on. Through trial and error, I have discovered that these deterrents to using acrylic as a transparent water medium were figments of my lack of imagination.

In this book I will share my discoveries with you in detail: how to make nonmuddy, glowingly transparent paintings both in watercolor and in matte acrylic, without endangering precious brushes. Both media are quite versatile and have marvelous possibilities; transparent acrylic is less well known than its more traditional cousin. Because the two media behave a little differently when applied to paper, I will compare and contrast their properties at each step of the discussion, and show you exactly how to use those properties to your advantage as you paint.

I hope this book will help you use pigments and brushes and water and paper to realize your own mental images in just the way you wish.

Studio Still Life by Julia Jordan. Transparent watercolor on d'Arches 140 lb. cold-pressed paper, 22 × 30" (56 × 76 cm). Collection of the artist.

MATERIALS, TOOLS, AND EQUIPMENT

Before discussing painting techniques that will help make transparent water media work for you, I want to tell you about materials that make painting success easier to achieve. Many beginning painters think it is wasteful to buy professional materials before they are proficient enough to paint "keepers." Ironically, student-grade materials often hinder students from painting "keepers," and if they become so discouraged that they give up painting, their materials expenditures are truly wasted.

On the other hand, I do not recommend that the student purchase large amounts of expensive materials and supplies before reaching the stage of true commitment to painting in water media. Rather, I counsel selectivity. It is better to buy three tubes of high-quality pigment (red, yellow, blue) than many tubes of student-grade paint. Just in case you do paint a "keeper," it is better to buy good-quality paper and make small works to begin with than to render large paintings on paper that will deteriorate. It is better to spend a little more on one excellent brush than to acquire a fleet of inferior brushes, none of which will make painting joyful. A quality brush can be amazingly versatile!

This chapter also provides some basic information about the materials of transparent painting: pigments, paper, brushes. A basic understanding of the history and manufacture of art materials is often helpful in selecting and respecting the ones you choose. All materials have advantages and disadvantages; few, if any, are perfect. I hope the following pages will help you in making informed choices about the materials and supplies that will work best for you.

PAINT

Acrylic and watercolor are considered water media because they may be thinned with water. "Medium" is, technically, the stuff that congeals particles of pigment into a paintable semifluid. For example, with oil paint the medium is linseed oil; with tempera it is egg yolk; with watercolor it is gum arabic; and with acrylic it is a polymer emulsion, a kind of fluid plastic. Thus water is *not* the medium for watercolor. Water is merely used to thin watercolor to a brushable consistency. (Naming watercolor after its thinner rather than its medium is as if we called oil paint "turpentine color" because it is thinned with turps.)

Mediums differ in the way they handle while being painted onto a surface, and also in the way they behave when dry. Watercolor and acrylic, thinned with water to a milky consistency, handle very similarly while you are painting with them. (Slight, but meaningful, differences will be described later.) It is after they are dry that the major difference becomes apparent. Dried watercolor can be dissolved again in water; acrylic cannot. To varying degrees, depending on the staining power of the pigments used, dried watercolor can be lifted off the paper by wiping with a damp sponge or scrubbing with a bristle brush or running the work under the shower. Several watercolor painting techniques and correctional methods rely on such "lifting off."

Certain drawbacks to painting in watercolor also can be traced to the fact that it is resoluble in water. Consider the unhappy (as opposed to the proverbial happy) accident. Once I had a landscape in progress that was developing wonderfully. As I was painting in the foreground beneath the clear, graded cobalt blue wash representing New Mexico's brilliant sky, a large drop of water mixed with yellow pigment fell off my brush into the middle of the sky. I still mourn that painting, for the dried pigment on the spot hit by the water bomb dissolved, and the sky had an irreparable hole in it! Had I been painting with acrylic, a quick swipe with a clean damp sponge or tissue would have removed the water spot from the dry sky without a trace.

Another technique that is easier with acrylic than with watercolor is glazing—laying down a wash over a dried painted area, to modify the color. A watercolorist of great skill can create a glowing effect as light penetrates layers of paint to the white paper below and bounces back. This can be achieved if the artist never strokes a loaded brush over a previously painted dry wash more than once. Unfortunately, less confident painters, using timid brushwork, create "mud" instead. This is because the initial passage of the wet brush over an already painted area loosens the dried paint below. The second (and each subsequent) pass mixes this loosened paint with the new paint on the brush. Instead of transparent layers of paint, a mush of colors is created, as when a mud puddle is stirred with a stick. If, however, you paint with acrylic, you may make as many passes as you wish, because the dried layers below will not dissolve no matter how hard you scrub. On the other hand, this property is sometimes a handicap with acrylic because dried (or even merely "set") passages of acrylic cannot be removed.

Besides being insoluble with water, dried acrylic paint becomes a transparent, porous, flexible film on the painting surface. If anything, acrylic is more transparent than "transparent" watercolor, assuming no white paint at all is mixed with the pigments, just as in traditional watercolor. Even the more "opaque" pigments, such as cadmium red and cerulean blue, seem more transparent in acrylic.

The porosity of dried acrylic allows you to rewet the paper through thin layers of dried paint; hence the behavior of the paper while painting will not be unfamiliar to a traditional watercolorist. It does take slightly longer for moisture to penetrate to the paper through layers of acrylic paint, but a small amount of patience will suffice. Porosity also means that a bumpy or wrinkled painting can be stretched after the fact by soaking and stapling. Water will penetrate the paper evenly, both from the back and through the dried paint on the front, but the paint will remain undisturbed unless scrubbed with undue vigor.

Flexibility is a factor that makes acrylic suitable for works on either paper or canvas—unlike, for example, tempera, which requires a stiff painting surface because it may crack if bent.

Compared to some media, watercolor and acrylic are relatively nontoxic, odorless, and acid-free (that is, they will not cause paper to deteriorate). Some experts believe acrylic to be somewhat less susceptible to ultraviolet rays than watercolor, rendering it more colorfast.

Many people believe acrylics to be brighter than watercolors. My perception is that there is little difference in the hues, but there is more color strength in acrylics. Therefore, a little color goes further; or, conversely, more water and/or medium needs to be added for very delicate washes. (This, plus the fact that a 4-ounce jar of acrylic costs less than a 15-milliliter tube of corresponding watercolor, should inspire thrifty painters to load up their brushes generously and plunge into painting as never before with watercolor.) If acrylic colors seem too garish, keep in mind that transparent colors can always be dulled down, but seldom can they be brightened up.

When painting in watercolor, I prefer professional-quality tube paints. Their greater purity and color strength make the purchase of less expensive student-grade paints a false economy. In general, Winsor & Newton watercolors seem to be the highest quality, but I often prefer the slightly looser consistency of Holbein colors. Since transparency is my highest criterion, I choose the sheerest pigments. Among these, I generally have on my palette a staining version of each hue and one that lifts off easily.

The staining colors I prefer are alizarin crimson, phthalo (or Winsor) blue, and new gamboge. (I avoid gamboge, which has an unpleasant greenish tinge and tends to look muddy when mixed with other hues.) Their nonstaining counterparts are aureolin yellow

(the Holbein version is warmer and more pleasing to the eye, but Winsor & Newton seems to have slightly more color strength), rose madder genuine (available only from Winsor & Newton, and then only sporadically), and cobalt blue.

Pigments available in acrylic are similar to those familiar to watercolorists: for example, the cadmiums, phthalo blue and green, cobalt and cerulean blue, and the earth colors. Missing are the alizarins, aureolin yellow, and a few others. As ample compensation, acrylic has a wonderful hansa yellow, quinacridone crimson, red, and gold. My acrylic palette consists of phthalo blue, cobalt blue, quinacridone crimson, quinacridone red, quinacridone gold, and hansa yellow.

There are several good brands of acrylics, but the brand I prefer is Golden matte acrylic paints. They come in easy-to-use jars rather than tubes, and when I began my transparent acrylic experiments, Golden was the only brand of *matte* acrylics and medium I could find. Most experts advise sticking with one brand of acrylics on the palette at any time, since chemical compatibility may vary from brand to brand.

You may have noticed that, whether in watercolor or acrylic, the colors I have included in my palette are only the primary hues: red, yellow, and blue. In each hue, for both acrylic and watercolor, I choose a high-key (light) and a low-key (dark) version. After years of trial and error, and a large expenditure of dollars on many of the tempting hues available in watercolor and acrylic, I realized I could mix any color I needed (including a convincing black) from the above-listed pigments. Furthermore, I found that I increased the overall color harmony of my paintings by limiting my palette.

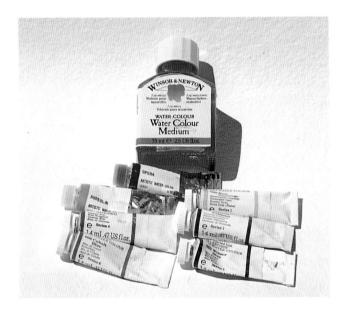

Tubes of watercolor and a bottle of watercolor medium.

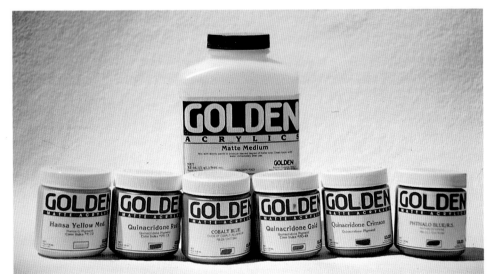

Jars of matte acrylic paint and medium.

PALETTES AND WATER TUBS

There is a wide array of palettes available for watercolor, but I prefer a covered palette with paint reservoirs and a large mixing area, such as the John Pike or Robert E. Wood palettes. The cover helps keep the paints from drying out between painting sessions; keeping a wet sponge inside the closed palette helps further. (When watercolor paint that has dried on the palette is remoistened, I find that undissolved flecks of pigment sometimes remain in the wash puddle, while intensity and purity of color seem compromised.)

At the beginning of a painting session, consider what pigments you are most likely to use, and squeeze a generous portion of each into the palette reservoirs.

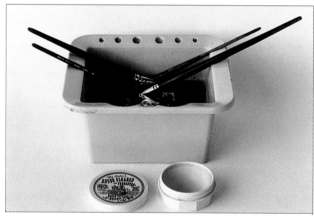

Brush basin with brushes and brush cleaner. The basin is filled only high enough to allow the hairs of the brushes to be immersed in water, but not the ferrules. The slanted brush rest keeps the brush hairs from bending.

The Painter's Pal palette. The white palette film is turned back to show the blue sponge below. Both are kept moist. The yellow lid is grooved and flexible to keep moisture in. The original paint cups have been replaced with solvent cups from Dick Blick, which are sturdier. In the cups, from left to right, are acrylic pigments: phthalo blue, quinacridone crimson, quinacridone gold, cobalt blue, quinacridone red, and hansa' yellow medium.

If these dollops of paint appear to be drying out during the session, a drop or two of water added to the paint reservoirs keep paints at a usable consistency.

I feel that a constant supply of clean water is essential to painting success, so I keep two large water reservoirs and one small one on my watercolor taboret. One large tub is for clean water, the other for dirty. The small one is my working container, which is emptied into the dirty tub when no longer clean enough to suit me. I then refill it from the clean tub. This arrangement evolved to allow me to have clean water handy at all times without continually running to the sink. Any kind of containers serve this purpose adequately.

Acrylic painting presents slightly different problems from watercolor. When acrylic dries on the palette, it cannot be made usable by rewetting. This may induce thrifty painters to be painfully stingy when doling out paint for a work session. Luckily, there is a palette available, the Sta-Wet Painter's Pal, that allows you to be thrifty and prodigal at the same time: thrifty in avoiding waste, prodigal in having enough paint at your brush tip to paint lavishly. The Painter's Pal has a tight-fitting cover, six covered wells for paint, and a flat sponge overlaid by a special paper film which, containing moisture, keeps mixed colors workable for hours of painting. With the lid in place, colors on the palette film remain moist overnight, while the paints in the cups are as safe as in the tube or jar. There is no reason the Painter's Pal would not serve equally well for watercolor, with or without the sponge/film base.

If acrylic paint dries on your brush, the brush will be ruined. There are few sights sadder than a fine brush permanently solidified with dried acrylic medium. Next worst is the accumulation of paint in the hairs close to the ferrule, causing the brush to splay and lose its resiliency.

To avert such tragedy, keep your brushes wet while painting, and wash them well at the end of each painting session. For acrylic I use a water tub called Brush Basin, which has slanted brush rests that keep the hairs unbent in water and the ferrules out. Whenever I switch brushes or walk away from the painting table, however briefly, the brush automatically goes in the tub. Usually a thorough wash with soap, till no more color comes out of the brush, is sufficient at the end of each painting session. But sometimes a brush will be in use for a long enough stretch that color will begin to cake around the ferrule while you are still working with it. It's a good idea to wash it immediately, using your thumbnail to gently urge the gummy paint out of the hairs. Any mild soap works well, but especially effective is The Masters' Brush Cleaner and Preserver.

BRUSHES

Of all the tools we use to make art, I think brushes are the ones to which we develop the strongest emotional attachments. Perhaps it is because they are extensions of our own hands. I've attended many workshops with well-known painters, who exhibited various degrees of brush fetishism. As a consequence, frequent workshop attendees tend to accumulate large collections of brushes acquired in hopes of absorbing some of the magic associated with the artists who recommended them. The brushes we *use*, on the other hand, tend to be relatively few and very personal.

Of my own large collection, the brushes I use the most are kolinskys: numbers 6, 8, 10, 1-inch flat and 1/2-inch flat. I like the way kolinsky hair behaves: When you load it up with paint and water, the load stays in the brush until you put it on the paper. (The little tragedy described on page 12, the water spot on the sky, happened when a loaded synthetic brush unloaded prematurely.) I also like the way kolinsky hair bounces back: Press the loaded brush hairs all the way down on the paper, then lift the brush up and see how the hairs straighten up. If you've spent much time painting with other natural-hair brushes (such as squirrel, ox, or others of unknown animal origin), the resiliency of kolinsky will at first seem like a miracle.

The difference between "kolinsky" and "sable" is mainly one of sex. (Here is one proven instance in which male is better!) Kolinsky brushes are made from the winter (that is, longer) tail hairs of the male Siberian kolinsky, a kind of weasel. "Sable" often refers to hairs taken from female kolinskys. Kolinsky hairs make great brushes because of their shape and texture. Each hair is pointed at both ends, bellies out in the middle, and has little spikes along its length that attract and hold water and paint. A good kolinsky brush is made so that you see only half the hair; the

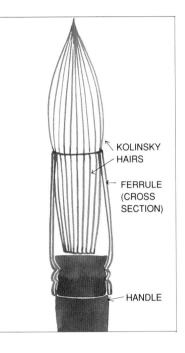

Cross-section of a kolinsky brush. This drawing illustrates how the kolinsky hairs are buried up to half their length in the ferrule of the brush.

KOLINSKY HAIRS

FERRULE (CROSS SECTION)

HANDLE

other half is secured inside the ferrule, with the "belly" at the ferrule's opening. Round brushes should come to a natural point when dipped in water and shaken.

I have bought several brands of kolinsky brush over the years, including the most famous ones, but I have enjoyed most working with the brushes sold by Daniel Smith under its company name. These quality brushes also have the virtue of being relatively inexpensive.

In recent years, certain synthetic brushes have come onto the market that attempt to imitate the desirable qualities of kolinsky at a lower price. They do fairly well with shape and resiliency, but their holding power is limited. A superior variant is the brush that combines kolinsky and synthetic hairs. Some of the best are Daniel Smith's, and these are truly affordable.

I have one synthetic brush handy at all times, and that is a Robert Simmons 3-inch flat called the Big Daddy. As far as I know, it is available only from Napa Valley Art Supply (see List of Suppliers). The Big Daddy is great for quickly prewetting large wash areas, because its precise edges allow fairly intricate painting action in addition to laying down large swaths of water.

The same brushes may be used for watercolor and acrylic. The relevant brush features of load-holding ability, edge and point precision, and resiliency are equally important for either medium. Even kolinsky brushes may be safely used for acrylic painting, if properly cared for. However, if it seems like too much bother to keep brushes wet when not actually in use, and to stop occasionally to wash them with soap, you may prefer to use one of the synthetic/sable combinations, which are far less expensive to replace.

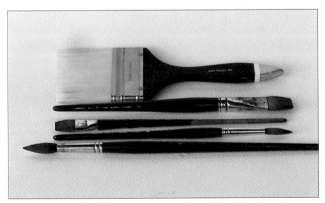

These are the brushes I use most often. From back to front: the Big Daddy, a synthetic wash brush 3 inches wide; a 1-inch flat; a 1/2-inch flat; a number 8 round; and a number 10 round. All except the Big Daddy are kolinsky.

PAPER

Paper is the traditional painting surface for watercolor, and thus also for transparent acrylic. Many see paper as a delicate or perishable support for a painting, an impression fostered by museum curators who "preserve" watercolors we yearn to look at by keeping them in drawers, out of sight and out of the light, which would presumably damage them. When early Georgia O'Keeffe watercolors were exhibited in Santa Fe several years ago, only 5 footcandles of light illuminated the paintings, which were difficult to see in the gloom. Two questions came to mind: Was this really necessary? And for whom were they being saved? The second question is rhetorical, but the answer to the first is probably yes in this case, since O'Keeffe, in her youthful poverty, painted on newsprint. Just as your daily newspaper yellows and crumbles at a tender age, so does any paper made from wood pulp or any other substance containing acid; this deterioration is accelerated by exposure to ultraviolet rays.

The old masters (such as Albrecht Dürer, whose five-hundred-year-old watercolors look fresh and bright even today) painted on "rag" paper, made literally from rags, usually of linen—the same substance of which canvas was made for oil paintings! Today's fine watercolor papers are mostly made from cotton lint (sometimes still obtained from rags) and are acid-free. Properly used and protected, they should have about the same durability as cotton canvas. Many less expensive papers available today contain wood pulp and have been "buffered" to neutralize acid in the material, just as chewing antacids buffers acids in the stomach. Such student-grade papers have not been exposed to the test of time the way rag papers have, so paintings on them have a relatively unpredictable future. Incidentally, it is important to realize that acid-free paper can be contaminated by contact with acidic materials, such as cardboard and unbuffered wood-pulp mats, or by exposure to polluted air.

There are three major paper manufacturing processes. Machine-made papers are the least expensive and can be recognized by their clean-cut edges and sometimes mechanical-appearing surface. Mold-made papers are in the mid-range of price and have two deckle edges and two torn edges. Handmade papers have four deckles, and are naturally the most costly.

The standard size for watercolor paper in the United States is about 22 × 30" (56 × 76 cm). The paper is made in varying thicknesses, or weights, based on the weight of a ream of paper (472 sheets measuring 22 × 30"). The most common weights are 90 lb., 140 lb., and 300 lb.; the thicker the paper, the higher the price. It is possible to buy oversized papers, such as "single elephant"

(26 × 40", or 66 cm × 1.02 m), "double elephant" (30 × 41", or 76 cm × 1.04 m), "triple elephant" (40 × 60", or 1.02 × 1.52 m), or rolled paper (44" by 10 yards, or 1.12 m × 9.14 m). The weights of these larger papers reflect their size, but usually correspond to 140 lb. in a standard sheet. Note that in Europe and other parts of the world, the standard sizes are different. Check with your local art supply store to see what sizes of paper are most readily available to you.

The texture of watercolor paper is another variable to consider. Hot-pressed is very smooth and relatively nonabsorbent. Rough is, well, rough. Picture a John Marin painting. The rough paper he favored is suitable for bold swaths of color and is the preference of many landscapists because of the textures implied by the minute shadows inherent in the surface of the paper. Cold-pressed is in the middle. Cold-pressed is called "not" in Britain because it is not rough and not smooth. It has enough texture to lend character to the painting surface and carry even washes, yet it is smooth enough for clear detail.

How do you choose a paper, with so many factors to consider?

First, I recommend that at the minimum a buffered paper should always be used, but preferably a rag paper. Who knows what "practice" piece will turn out to be a keeper, treasured by someone years from now? O'Keeffe probably expected a short life for her early watercolors. Now they are a conservationist's nightmare and a source of frustration for would-be viewers.

Machine-made, mold-made, or handmade? My preference is mold-made, which has a pleasing surface character at a reasonable cost and seems a little stronger than handmade papers.

A choice of weight depends to some degree on painting size and style and whether you choose to stretch the paper. The thinner the paper, the more it tends to buckle when wet. The larger the painting, the more buckling is a problem. And stretching reduces buckling, but also stresses the paper. (The lighter the paper, the more likely it is to tear when stretched.) So, for very small, very dryly painted, unstretched work, 90 lb. paper should be fine; but obviously the usefulness of 90 lb. paper is limited. To be tempted by its relatively low price could well be false economy. The most popular weight is 140 lb. It is moderately priced and sturdy enough to withstand stretching. Artists who do not care to stretch their paper often choose 300 lb. paper. It buckles some but does not become impossible to work with when wet, unlike the lighter weights.

Paper texture is a relatively simple choice. Hot-pressed paper, being less absorbent than cold-pressed

or rough, allows more color to remain on the surface, which makes a painting look brighter. It is also somewhat easier to lift off watercolor from hot-pressed paper than from papers with rougher textures. Large areas of watercolor wash appear streaky on hot-pressed paper, though this is less true of acrylic washes. Finally, extremely tight rendering is easiest on the smooth, hot-pressed surface.

Cold-pressed paper, as mentioned above, seems to have the widest range of usefulness, and is the most popular. Rough is great for landscapes, broad-brush effects, and textures.

Having tried all kinds of papers, I have found d'Arches, a durable mold-made cotton paper, to be the most satisfactory and reliable at a reasonable price. One reason the price is reasonable is that the popularity of this paper results in a high enough sales volume to bring the price down. I usually use 140 lb. cold-pressed, though I stock all three textures and also 300 lb. weight.

Some watercolor papers. From top to bottom: Indian Village handmade, rough (Daniel Smith); Fabriano Esportiazione handmade, cold-pressed; d'Arches mold-made, hot-pressed; d'Arches mold-made, cold-pressed; d'Arches mold-made, rough; Daniel Smith student grade, machine-made, "cold-pressed." Note that the deckle edges on the handmade papers are the same on both edges, while the mold-made papers have real deckles on the bottom and torn edges on the sides. The machine-made papers have no deckles.

When you wet watercolor paper, the water is absorbed into its fibers, swelling the paper. Unless the entire sheet is thoroughly soaked, dry areas remain relatively unswollen, creating hills and valleys on the surface. As you paint on this uneven surface, gravity pulls water and pigment into the low spots, creating puddles, while the area where the paint was originally applied is drained. Next, water from the puddles seeps back into the drier (but not totally dry) area you just painted and makes backruns. When the paper dries, it dries bumpy. (This scenario assumes a painting technique in which plenty of water is used; the effects will not be so apparent with a dry-brush style.)

If these effects annoy you (as opposed to being seen as happy accidents), they may be prevented by stretching the paper. The principle of paper stretching is also based on the fact that paper swells when wet and shrinks as it dries. To begin, the paper must be thoroughly soaked. Soaking can be a headache if you believe the paper must have a tub bath. If you put it in the tub, the tub must be quite clean or the paper may pick up body oils which create resist spots where paint won't adhere properly. Rather than clean the tub every

The first step in soaking watercolor paper is to spread out a generous piece of plastic sheeting and then sponge the paper liberally with water.

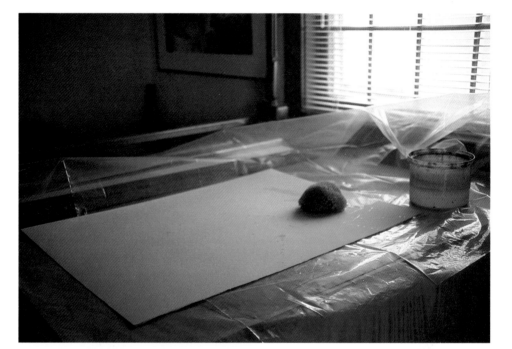

The second step is to fold the plastic sheeting around the wet paper and allow the water to penetrate the paper for about half an hour. The sheeting keeps water from evaporating and allows even penetration of the paper.

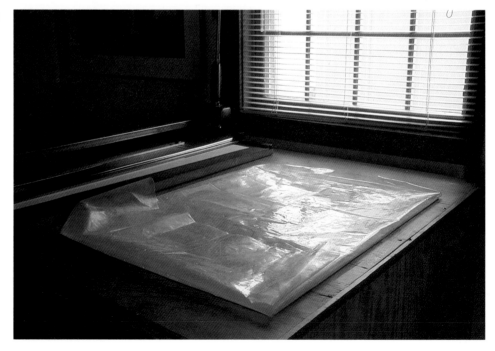

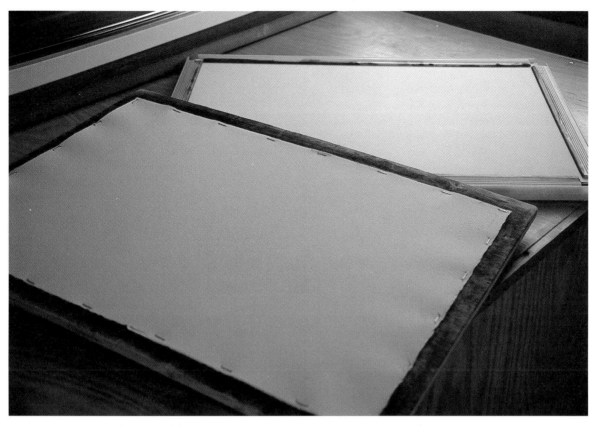

Stretched paper: The foreground paper has been stretched using a staple gun. The background board uses Zipp Clamps to grip the edges of the paper.

time I want to stretch paper, I lay the paper atop a sheet of plastic large enough to wrap the watercolor sheet (for example, a dry cleaner's bag or plastic drop cloth), sponge it generously with water (natural sponges are less abrasive than synthetic), wrap it up, and let it sit for about half an hour while the water penetrates all the fibers of the paper. The plastic sheeting prevents evaporation. Note that too long a soak can weaken some papers, though d'Arches doesn't seem to mind an overnight wait.

Next, the wet paper needs to be mounted on a board and secured at the edges so that it is evenly pulled taut while the evaporation of the water causes the paper to shrink. This tautness is sufficient to prevent significant buckling while painting is in progress, and causes the painting to dry flat. Ideally, the paper should remain secured to the board until the painting is finished and dry. Once released from bondage on the board, stretched paper does not remain stretched; it will behave just like any other unstretched paper.

Still, there are times when an incomplete painting must be removed from the stretching board. To restretch a watercolor is hazardous; it is best to spray carefully only the back with water, lay the painting face down on an absorbent surface, cover it with plastic sheeting, and allow it to percolate for about half an hour. Then restretch it. If the work in progress is acrylic, the original stretching process may be repeated without danger.

To secure the soaked paper to the board, I have found two methods that are effective most of the time. The first is staples, spaced about 2 inches (5 cm) apart, roughly 1/4 inch (.6 cm) in from the edge of the sheet. A power stapler is essential equipment here. Occasionally, if a sheet has absorbed too much water, the weakened paper will pull away from the staples, creating small tears; but moderation in soaking time solves the problem. The only other occasional drawback to this approach is that water tends to collect in the staple holes while you paint, creating backruns around the staples. Soak up this water with a thirsty brush (clean, damp, squeezed out) or allow for a wider mat when framing the finished piece.

An alternative tool for stretching paper is the Zipp Clamp System (see List of Suppliers for source), which grips the watercolor sheet evenly with clamps held tight with plugs that pull out like a zipper when the painting is done. An advantage of this system is that the finished painting has no untidy staple holes along the edges, but rather a clean white half-inch border instead. If anyone ever sees your work in an unmatted state, this clean edge makes a better impression.

There are legends of people who use paper tape to secure soaked paper to a board. I don't know any such people, and when I tried this myself, the tape didn't hold to either the paper or the board, and the paper dried to resemble the Appalachian Range.

OTHER EQUIPMENT

Paint, palette, brushes, paper, and boards are all sine qua non—that without which it is virtually impossible to paint. Other desirables include a table, proper lighting, a subject to paint, and miscellaneous little helpers.

On this page is a photograph of my workspace, which has evolved through trial and error to be quite utilitarian.

I generally stand to paint, but when I get into teeny-tiny details, a chair that supports my back is nice to have handy. The floor mat is designed for easing foot strain and secondarily keeps some of the stray paint off the floor. The lamps simulate daylight by combining a fluorescent and an incandescent bulb. The window faces north, as all studio windows in the Northern Hemisphere theoretically should (preventing blinding sunlight from falling directly on your painting surface). Alas, it is shaded by a ramada, or patio roof, and is therefore supplemented by a skylight directly above the painting table. The taboret to the right is actually designed for kitchen use, but works quite well. Just in case I ever want to use it in the kitchen again, I protect the butcher-block top with a sheet of Plexiglas.

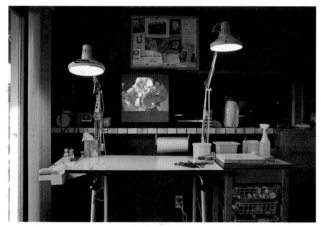

This is my workspace. Although there is north light, a covered patio reduces its intensity. There is also a skylight over my table that provides good light on sunny afternoons. For reliable light at any time, I count on two combo lamps that mimic daylight. The screen on the ledge in front of the table is a rear projection screen, and the projector is behind it, in the kitchen (see below). To the far left of the screen can be seen a compressor to power an airbrush, which I use from time to time. To the right on the ledge is an answering machine that I turn on to prevent interruptions when I am undertaking large or tricky washes. To its right is a gallon jar filled with water, where I always keep a sheet of palette film soaking for the Painter's Pal. The taboret is set up for acrylic painting, with a yellow-lidded Painter's Pal palette. The paints themselves are in the bins below.

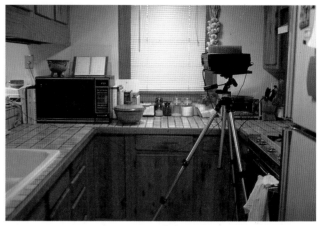

Here is the projector in my kitchen, which is barely wide enough to allow enough distance between the projector and the screen to fill the screen with a slide. If I want to focus on a detail of a slide, I place a cardboard box on the stove and rest the projector on top of it. The image on the screen is brighter if I keep the kitchen dark.

Something to paint: If you paint from your imagination or sketches, from still life setups or on site, you may want to skip this section, for I paint from photographs, Despite all the imperfections of image implicit in photography, and despite the backhanded compliments my work sometimes elicits ("It looks just like a picture!"), photographs capture best the aspect of visual beauty that excites me most: the evanescent light and its gross and subtle, quickly changing effects. Justification aside, my visual reference has evolved from oversized prints (expensive and ever harder on aging eyes) through slides in a 5 × 7" viewer, to my present rear-projection screen and slides projected from the kitchen next door to the studio. The latter arrangement is completely satisfactory (or would be, if only my kitchen were wider), in allowing me to paint from large, clear, brilliant images right before my eyes. My slide projector is the most common type, supported on a heavy-duty camera tripod topped with a special platform available from photo supply stores (see List of Suppliers). The use of a tripod allows me to adjust the height and angle of the projector easily and is much less hazardous to the machine than, for example, piling up cardboard boxes (my initial solution).

Little indispensables around the work area include a small hair dryer, Winsor & Newton colorless masking fluid, a masking pickup, an eraser, an X-Acto knife, a water-spray bottle, a small spouted bottle for adding small quantities of water to mixed colors, a cake of brush-cleaner soap, a sponge, jars of brushes, a palette knife for adding paint to the cups, tissue and paper towels, a folded absorbent cloth to remove excess

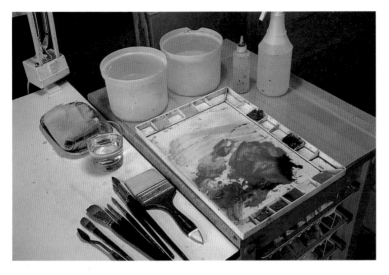

Taboret arrangement for watercolor. Clockwise from top left: an absorbent cloth, which I spray with water at the beginning of a session to enhance absorbency; a container for dirty water; a reservoir of clean water; a spouted bottle for adding water to paint puddles; a spray bottle; a John Pike palette containing new gamboge, aureolin yellow, cobalt blue, Winsor blue, opera, rose madder genuine, alizarin crimson, and brown madder (alizarin)—an occasional pigment; an assortment of brushes; a palette knife; and a glass of clean water. The glass of water is used to wet the brush or add water to a loaded brush. It slowly accumulates pigment, and when I judge it "dirty," I empty it into the tub for dirty water and refill it from the clean-water reservoir. To clean brushes, I swish them in the dirty-water tub.

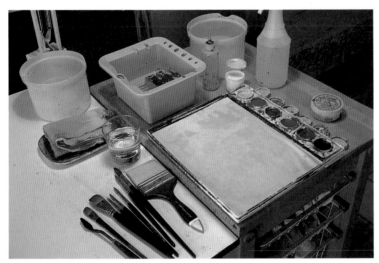

Taboret arrangement for acrylic. Additions to the watercolor supplies include a brush basin to keep brushes wet at all times; a small jar of matte acrylic medium; a container of brush soap; and a Painter's Pal palette, containing a wet sponge covered by palette film, which keeps puddles of paint moist while I'm working.

moisture from loaded paint brushes, a small jar of matte acrylic medium, and several water containers.

Each artist gradually develops preferences for certain materials and equipment, based on temperament, style, and work habits. The materials described in this chapter may or may not suit your individual needs or pocketbook, but I think many of them fill requirements imposed by the very nature of transparent painting on paper. The main thing in choosing your equipment is to meet these general requirements (just to be able to work with a minimum of inconvenience), as well as your own idiosyncratic preferences, as economically as possible. Finally, remember that although particular items in a well-equipped artist's collection of tools may be expensive, the amount of money spent does not necessarily reflect an item's usefulness.

I hope this chapter will serve as a useful guide when you select the materials and equipment that will suit you best.

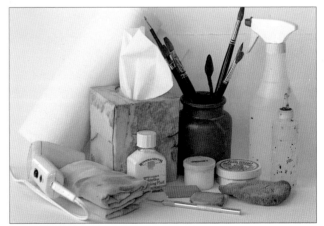

Painting accessories: Paper towels, tissues, a jar of brushes, a spray bottle, a spouted bottle, a natural sponge, brush cleaner, a small jar of matte acrylic medium, a rubber pickup for masking fluid, an eraser, an X-Acto knife, a bottle of masking fluid, an absorbent cloth, and a hair dryer.

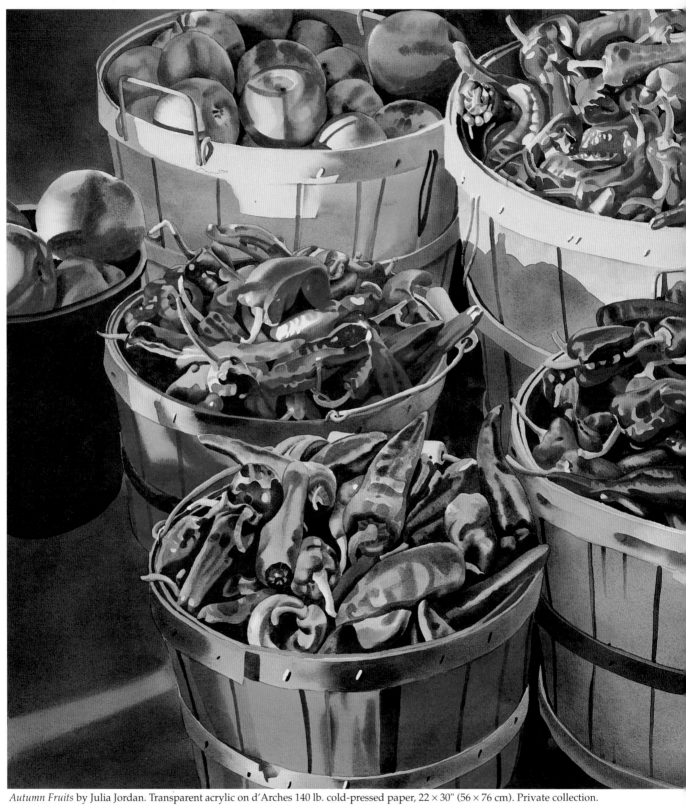

Autumn Fruits by Julia Jordan. Transparent acrylic on d'Arches 140 lb. cold-pressed paper, 22 × 30" (56 × 76 cm). Private collection.

Julia Jordan

PLANNING A TRANSPARENT PAINTING

Water media painters tend to fall into two major groups, depending on whether or not they plan their paintings. The inductive painters are those who begin in a playful frame of mind with loose washes or impulsive paint marks or splotches, and discover the subject and mood of the painting as they go along. The results are often beautiful, tending toward the abstract. Deductive painters begin with more focus. They may be open to happy accidents or new insight as the work progresses, but there is purpose and method from the outset, aimed at manifesting a fairly clear mental concept. Deductive painters tend to produce realistic images.

I count myself among the deductive painters, and this brief chapter is oriented to deductive, or planned, painting. If the exploratory approach is more to your liking, you may wish to plunge into the next chapter, on painting techniques, right away.

WHAT IS YOUR PAINTING REALLY ABOUT?

Whether you are working from nature, a setup, a value sketch, or a photograph, it is helpful to ponder briefly the objective of the prospective work before making any marks on the paper. For example, is this painting about light moving across the page from right to left? About an overall pattern of vibrant color? About dramatic value contrasts? What is the most salient visual feature of the subject matter, the quality or qualities that make you itch to create a painting? What made you fall in love with this subject matter? (If you are not in love, is it really worth making this painting?) This moment of contemplation could well be the most important that occurs in the entire process of making

a piece of deductive art, for the thoughtlessly begun painting may be doomed to failure from the first brushstroke. As explained above, inductive painting is another process, in which you discover as you go along and therefore don't necessarily have to answer all these questions beforehand.

In contemplating the subject of the work about to be begun, consider the context. If the subject itself is of sole importance, and its context is of little interest, you could consider filling the entire picture plane with it—omitting any background. On the other hand, if maintaining the mood that attracted you to the subject requires a representation of the setting, how much of

Floral Rhythm by Barbara Nechis. Transparent watercolor on d'Arches 140 lb. cold-pressed paper, 15 × 22" (38 × 56 cm). Collection of the artist.

Barbara Nechis is a well-known teacher and watercolorist. Above is an example of her work. Barbara says, "I certainly am an inductive painter. I start with a tabula rasa. In most paintings a subject occurs early, but only as a possibility, so that my strokes could be flower or landscape forms. But at

no time is there an image in my head—only a thought process as to how to fit the shape being placed to the one next to it. Since nothing is planned, the procedure can create design problems, and the work and play are the involvement in solving them."

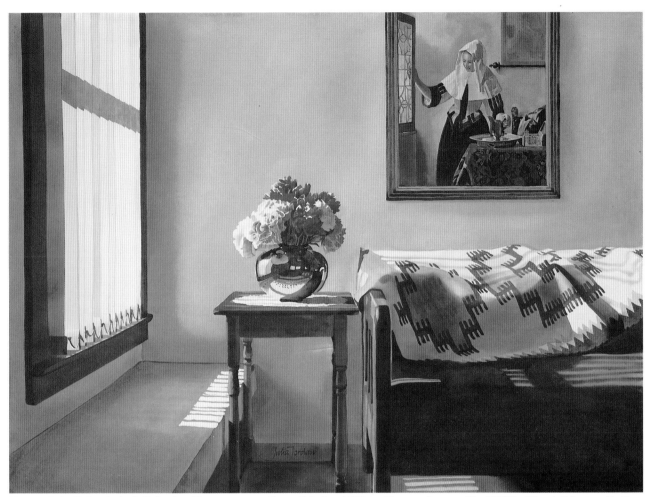

Vermeer Series II: Peonies by Julia Jordan. Transparent acrylic on d'Arches 140 lb. cold-pressed paper, 22 × 30" (56 × 76 cm). Private collection.

This example of a deductive painting is one of my most planned because its design is very conceptual. Usually I paint scenes or found objects that strike me as beautiful. This design is constructed intentionally to mimic Vermeer's room arrangement and light source.

I replaced the Oriental carpet he often used as a table covering with a Navajo rug flung over the couch, and incorporated a reproduction of his painting Woman with a Water Jug *(oil on canvas, about 1662, 18 × 16" [46 × 41 cm], collection of Metropolitan Museum of Art, New York).*

Most Vermeer interiors include a painting or map on the wall. However, Vermeer never, to my knowledge, included flowers in his paintings, and the kind of intense sunlight found in New Mexico never came through his window in Delft. Here the peonies are a substitute for the pretty woman in the Vermeer painting.

the setting is necessary and sufficient? Background and foreground material that is boring to *your* eye will also be boring to the viewer. Boredom shows!

A trick for zeroing in on the essence of your subject, or choosing an overall composition, is to make a little window or viewfinder to look through. A slide mount from which the film has been cut with an X-Acto blade does very well. Hold it up to your eye and move it back and forth till the image in the frame is pleasing to you.

Before beginning to draw, you may want to consider editing out any details that are confusing or fail to contribute to the impact of the image. Adding details is also possible, but for a realistic image it is worthwhile to consider how any additions will interact with the existing context, particularly the configuration of light and shadow.

Complementary Bouquet by Julia Jordan. Transparent acrylic on d'Arches 140 lb. cold-pressed paper, 22 × 30" (56 × 76 cm). Collection of Stuart Patterson and Elinor Schrader.

This painting focuses on what interested me most about the subject: the contrast between the yellow and purple flowers with their complementary colors, the glow imparted by the sunlight from behind, and the lacy, glowing cast shadow. I have not included the whole bouquet because my goals were completely met by a part of the whole. Closing in on the cropped subject immerses the viewer in its mood, rather than allowing him or her to keep a distance from it.

EDITING THE IMAGE

A drawing as a plan for a painting serves a different purpose from, and thus looks different from, a drawing made for its own sake. The more minimal the plan drawing, the less it will interfere with the painted image. You need only enough to keep from getting lost while painting. How much drawing is enough depends on the amount of detail in the subject and the degree to which detail is desired in its representation. Some subjects are inherently rife with repetitive detail, and a detailed rendering requires a careful drawing to avoid hopeless confusion. For example, think of bunches or masses of flowers, piles or baskets of fruit, complex architectural details, groups of people, piles or mountains of rock. Some subjects are so overwhelming in their detail that artists seldom try to approach a detailed rendering of them: broad landscapes, seascapes, treescapes, or gardens. These may in fact be represented very simply, and often impressionistically, with a minimum of plan drawing.

Having considered overall composition and crucial shapes, you might look within the image for logical divisions of the sheet of paper, drawing these divisions first, and narrowing to details within those divisions, looking always at the relationships of shapes and proportions and trying to forget what you rationally know about the subject as opposed to what you *see*.

Here is the plan drawing for Hollyhock Quartet III, *one of the flower demonstration paintings in Part Four. The flowers are complicated in their light and shadow patterns, making it easy to get lost in the shapes. For this reason I projected the slide onto the watercolor paper to facilitate rendering, but drew only as much of the outline as I felt necessary to find my way when I began painting.*

This is an example of drawing for its own sake. It is the same subject matter, this time drawn freehand, and concentrating on drawing technique and rendering light and shadow in pencil. A drawing like this would be an obstacle to painting rather than a help. It is intended to stand on its own as a work of art.

ENLARGING A SKETCH WITH A GRID

Sometimes it is difficult to make a direct translation from the subject matter in the viewfinder to a plan drawing on watercolor paper. It is more manageable visually and mentally to make a small compositional sketch, or several, to clarify the significant shapes and their arrangement on the page. This drawing can be blown up either by "eyeballing" (estimating) or by drawing a grid over the small drawing and proportionately

enlarging the grid and its related planning marks to the size of a watercolor sheet. The grid helps to synchronize the visual relationships of shapes and their placement on the page. This process is mathematically simplified if you begin by making the small drawing proportionate to the watercolor sheet you intend to use. Obviously, a *very light* drawing of the grid on the watercolor paper will make for its easier erasure later.

It is easy to enlarge a sketch proportionately without higher mathematics by laying a straight edge diagonally across the smaller drawing and the larger sheet. Where the straight edge meets the far edge of the watercolor sheet is where it should

be cut to make a proportionate shape. Then divide both the watercolor sheet and the sketch into halves and quarters, and the grid will also be proportionate. This method is very helpful for enlarging a thumbnail sketch into a plan drawing.

IMPROVING DRAWING SKILLS

Drawing is a skill that can be learned and perfected. While I have the impression that most people begin to think of themselves as artists because they find drawing easy when they are young (for example, by popular acclaim they were the best "drawer" in the third grade), ironically, many painters have difficulty with the drawing stage of making a painting. I suspect that this is often due more to a lack of focus on the purpose of the painting than to an inability to draw. Nevertheless, I would like to note here that nearly anyone can develop a high level of drawing skill. This has been stunningly demonstrated by Betty Edwards in her work to enhance creativity in ordinary people—that is, those who do not identify themselves as artists. (See her book *Drawing on the Right Side of the Brain*, published by J.P. Tarcher, Inc., Los Angeles, 1979.)

So now, because of Edwards's work, we know that drawing is rather like cooking: some people seem to have an innate flair for it, but anyone can learn to do it, given the right approach and enough practice. Drawing is also like cooking in that, after you have done it skillfully—but routinely—for years, it can become rather tedious. This is particularly true of plan drawings for paintings (as opposed to drawings for their own sake).

PLAN DRAWINGS FROM PROJECTED IMAGES

Late in life, Norman Rockwell, renowned for realistic paintings of the American scene, admitted that he often projected photographic images onto his canvas and traced outlines of shapes, to speed up the drawing process. Beginning in the eighteenth century, many well-known painters relied on the camera obscura, a precursor of the modern camera, to project images to facilitate the drawing stage. And today, many realistic artists draw from projected images, although this practice seems to be frowned upon by others. Recalling our opening motto "All's fair in art," it does not seem appropriate to make moral judgments about plan drawing methods; the result speaks for itself.

There is no question that detailed rendering of complicated patterns can be speeded up, and possibly improved, by projecting the image to be drawn. However, it should be noted that there are pitfalls here, too. Without a clear idea of the intention of the painting, the artist may get lost in the detail of the projected image and produce a plan drawing with no focus or economy. The resulting painting may never achieve resolution. Also, unless the projected image is perfect as is, artistic choices—cropping, omissions, rearrangement of shapes—must be made during the rendering process. The great hazard with projecting slide images for plan drawing is not so much sacrificing artistic integrity as failing to remain artistically conscious during the process—that is, succumbing mentally to the mechanics of the rendering process and producing as a result a mechanical drawing, hence an insensitive painting.

To summarize, purposeful painting benefits enormously from planning marks based on a thoughtful consideration of the intention and focus of the prospective work of art. Regardless of the method used to develop the drawn image, maintenance of artistic attention during the drawing phase is vitally important for the ultimate success of the painting. It is more important to avoid a mechanical frame of mind than a mechanical method during this stage of the development process. The vitality of the finished piece may actually suffer more if the painter experiences tedium while conscientiously drawing freehand than if a projected image is used sensitively to speed up the planning stage and move on to the excitement of making a painting.

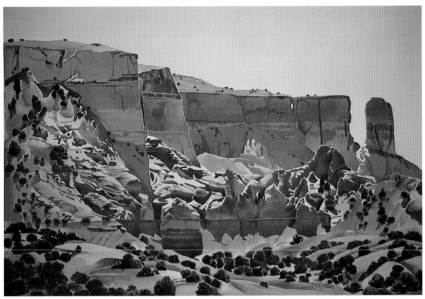

Because I knew I could easily become lost in the small rock shapes of the middle ground, I chose to project this image to make the plan drawing. When the painting was finished, I realized that, while it was not a throwaway, it didn't convey the magic I had intended. Perhaps it had "too many notes," as the emperor said to Mozart.

Light from the East by Julia Jordan. Transparent acrylic on d'Arches 140 lb. cold-pressed paper, 22 × 30" (56 × 76 cm). Collection of Rae and Michael Winderbaum.

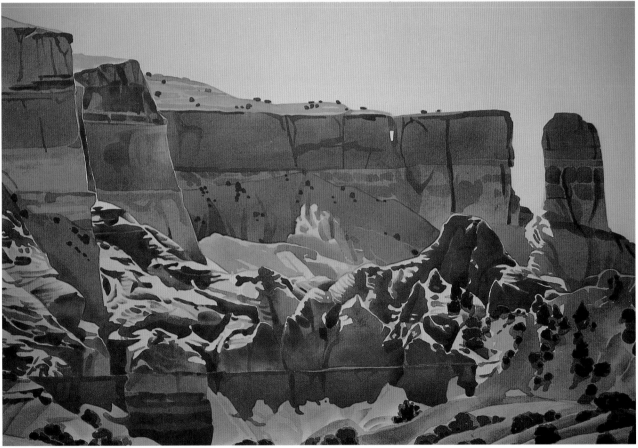

Light from the East, *detail. Using my camera viewfinder to crop the piece visually, I zeroed in on the part of the painting that seemed to me the most powerful. Reluctant to sacrifice the full sheet size and all the work that would be thrown away if I cut the painting, I decided to paint a second version, concentrating on this part of the composition.*

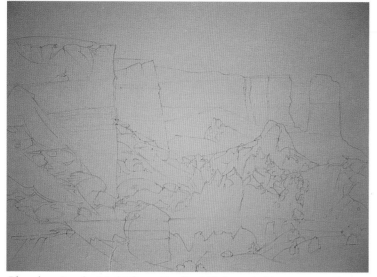

Plan drawing for Light from the East II. *I wanted to compress the image horizontally to include more of the left-hand cliff without including too much of the foreground hilly area (which I found boring to paint). To achieve this, I chose to draw freehand this time. Doing the first painting had enhanced my understanding of those confusing rocks in the middle ground, so that this time I could simplify them and avoid getting lost. As I began this painting I was much surer of what I was after.*

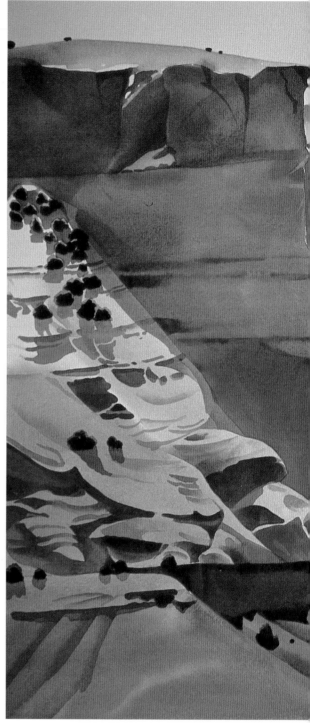

I think this second version is compositionally more successful than the first, and packs more of a punch with its relative simplicity.

Light from the East II by Julia Jordan. Transparent acrylic on d'Arches 140 lb. cold-pressed paper, 22 × 30" (56 × 76 cm). Collection of Jim Wittemore.

White on White by Julia Jordan. Transparent watercolor on d'Arches 140 lb. cold-pressed paper, 22 × 30" (56 × 76 cm). Private collection.

TRANSPARENT TECHNIQUES

Transparent painting is the application of thin washes of pigment to white paper in such a way that no layer of pigment completely covers a previously painted layer, and the white of the paper always seems to glow through the color. The dried washes are "transparent" in a way similar to the way colored cellophane is transparent. Just as you could layer cellophane of different colors to achieve a third color (for example, a blue sheet laid over a yellow sheet would create a green effect), transparent paints can be layered to create different color effects. This is called glazing.

Because adding white pigment causes colored transparent pigments to become opaque (that is, gives them covering power), transparent painting avoids the use of white paint and relies instead on the white of the paper. Instead of adding white to a pigment to lighten it, in transparent painting you add water to thin the pigment, so that more of the white paper shows through. For white areas, the paper remains unpainted.

As stated in Chapter One, watercolor is unusual among painting media in being named after its thinner rather than its medium (the substance that holds the pigment particles together). Perhaps the reason for this is that water—and the physical laws that govern its interaction with paper and pigments—so overwhelmingly dominate the technical aspects of painting in water media. Because the most challenging technical problems in water media are water-based, this chapter will begin with a discussion of controlling wetness on your brush and paper. We will go on to cover brushwork, textures, color and pigments, and the painting process itself.

WETNESS CONTROL: GRAVITY AND CAPILLARY ATTRACTION

I asserted earlier that all's fair in art, and that the only applicable laws are the laws of physics. Many artists have an innate aversion to physics and its terminology, and I am no exception, so this discussion will be in outrageously simplified terms.

In transparent water media painting on paper, the most relevant physical forces are gravity and capillary attraction. By this I mean that water runs downhill, and that while damp paper attracts moisture, dry paper resists it. That's all! It sounds so simple. Still, if you have ever toiled through a physics course, you recall how all the implications of a briefly stated principle could be crystal-clear to the teacher but mysterious to the students.

Let's get concrete. First, because it is so obvious: When water runs downhill on your painting, it is either because the painting surface is tilted or because hills and valleys have formed on the paper. Some painting effects of gravity are drips, runs, and puddles forming in valleys. To stop water from running downhill, you need to paint on a horizontal surface and stretch your watercolor paper.

Capillary attraction is more complex. When people begin to paint transparently in water media, they usually encounter frustration in the form of backruns (or blooms): unhappy accidents where the edge of one wet wash meets the edge of another, and the two washes begin to interact. Or newly applied marks seem to go wildly out of control when placed in an area that is already wet. A fundamental understanding of the main principle of wetness control (or controlling capillary attraction) will end these frustrations. Briefly stated, *damp attracts wet; dry resists wet.*

What this means for your painting is that when wet and damp areas on a painting meet, they'll be attracted to each other and pull pigment around when they interact. The direction of the attraction is that the damp area sucks up moisture from the wetter one, carrying

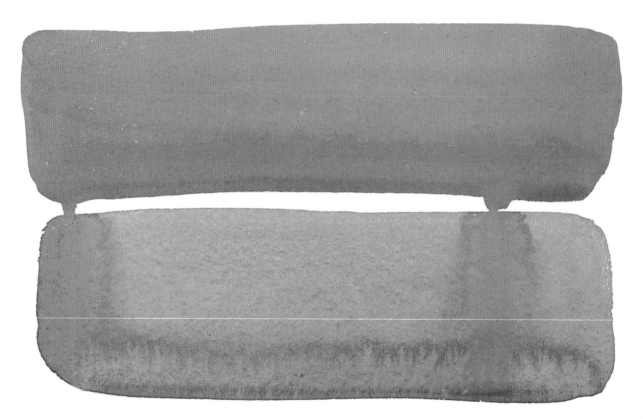

One wash invades another because of gravity. The painting surface was vertical.

One wash invades another by capillary attraction. The wash on the left was damp when the wash on the right was painted adjacent to it. The damp wash pulled in moisture and pigment from the wetter, newer wash.

along any pigment that is in the wetter area and redistributing it rather unpredictably in the drier area. On the other hand, a wet mark laid down on *dry* paper tends to stay where it is put, with nice tidy edges, because the dry paper resists the infiltration of the moisture long enough to let the pigment in the mark set somewhat.

This damp-to-dry relationship holds not only between different areas on a piece of watercolor paper, but between the paper and the brush. For example, if you have a damp (that is, partially dry) wash on your paper, and you touch that area with a wet brush, the damp area will suck water out of the brush (along with any pigment mixed with that water) and move it around a little, creating an irregular spot that is lighter than the surrounding wash, with a ridge of pigment separating the paler spot from the wash. This effect is called a bloom or backrun.

On the other hand, if there is a really wet wash on the paper, or if the paper has been painted liberally with clear water, and you stroke it with a brush that is *less wet* than the paper, the brush will soak up moisture—and some pigment, if there is any—from the paper. This is called applying a thirsty brush. And if the thirsty brush has a damp load of pigment, the mark it will make on the wet paper will be softened, because the drier pigment stroke sucks up moisture from the paper. These and related effects will be described more specifically below, where we compare the behavior of watercolor and acrylic.

Generally speaking, watercolor and acrylic behave quite similarly with regard to capillary attraction, except for the fact that watercolor is runnier and acrylic seems to set up faster than watercolor. The implications of these differences will be discussed in conjunction with each effect described.

WET-IN-WET: AMORPHOUS COLOR SHAPES

If there is a shiny wet wash (either pigmented or clear) on the paper, and you quickly drop into it brushloads of equally wet or slightly wetter pigment, the color thus introduced will swim around pretty freely in the wash, blending and combining to create fairly unpredictable soft-edged shapes. Because the previous wash and the new color are about equally wet, there is little capillary attraction. You can also increase the amount of movement and blending by pushing color around with your brush.

Because watercolor is runnier than acrylic, wet-in-wet strokes made with acrylic are more likely to keep a kind of shape than those made with watercolor.

SOFT-EDGED SHAPES

To create soft-edged shapes with more definition and control than achieved with wet-in-wet, you can simply modify wetness relationships. If, for instance, there is a shiny wet wash (clear or pigmented) on the paper, you can introduce into it a stroke with a brush loaded with relatively thick paint, that is, paint containing *less* water than the wash on the paper. The damp (or less wet) stroke of paint will attract moisture from the surrounding wash, which will soften the stroke. If the difference in wetness between the paint stroke and the wash is too great, there may even be backruns from the wash into the stroke. (It requires practice to get a feel for how these relationships work.)

As with wet-in-wet, an acrylic stroke made in this manner will hold its shape better than a watercolor stroke. To compensate for this difference, either the acrylic stroke could have a little more water in the paint, or the watercolor brushload would be a little stiffer, to achieve similar results. Because watercolor is runnier than acrylic, there is some danger that pigment will spread out to the edge of the wash or prewet area, creating a hard edge of pigment where the wetness ends. Either increasing the breadth of the wash or the stiffness of the watercolor paint will reduce this risk.

Another way to create a soft-edged shape is to paint the shape on dry paper and soften some or all of the edges immediately afterwards with a clean, wet (but not dripping) brush. This works best with small shapes, because the paint is setting up and becoming more difficult to soften every second. It also works better with watercolor than acrylic, both because acrylic sets up faster and because watercolor will dissolve somewhat with the passage of the wet brush over it. If the watercolor painting is in its later stages, there is some hazard here of softening adjacent edges unintentionally, so the clean, wet brush should pass over the edge of the new shape no more than once.

If, in using the first, prewet approach with acrylic, you find the shape more sharp-edged than desired, you can then go back with a clean, damp (not wet) brush and further soften the edge. There is no need to worry about unintentional softening of adjacent dry edges with acrylic, because these will not dissolve in water.

Here you see amorphous shapes made by dropping wet paint onto wet paper and allowing pigments to blend.

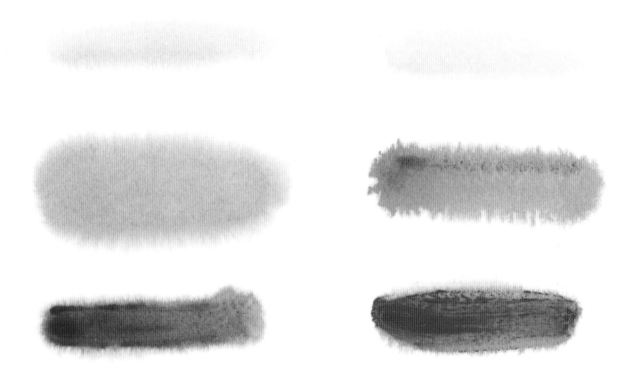

The key to fuzzy, shapely marks is to have less moisture on the brush than on the paper. To make a light mark, as at top, press the brush firmly against an absorbent cloth to remove most of the water but leave some pigment behind. The bottom pair of marks are made with thick paint right from the tube.

The marks on the left are watercolor; those on the right are acrylic (cobalt blue). Notice that the middle watercolor mark has spread out more than its acrylic equivalent, while the greater wetness on the paper has caused backruns into the middle acrylic wash.

For softened edges in watercolor, overpainting the stroke with a clean, wet (but not dripping) brush works best, as on the left. In acrylic, as on the right, first prewet, then make the stroke. Overlap the prewet area for a crisp edge, but stay within the prewet area for a soft edge. Finally, moisten the soft edges again with a clean, damp brush.

WATERCOLOR

ACRYLIC

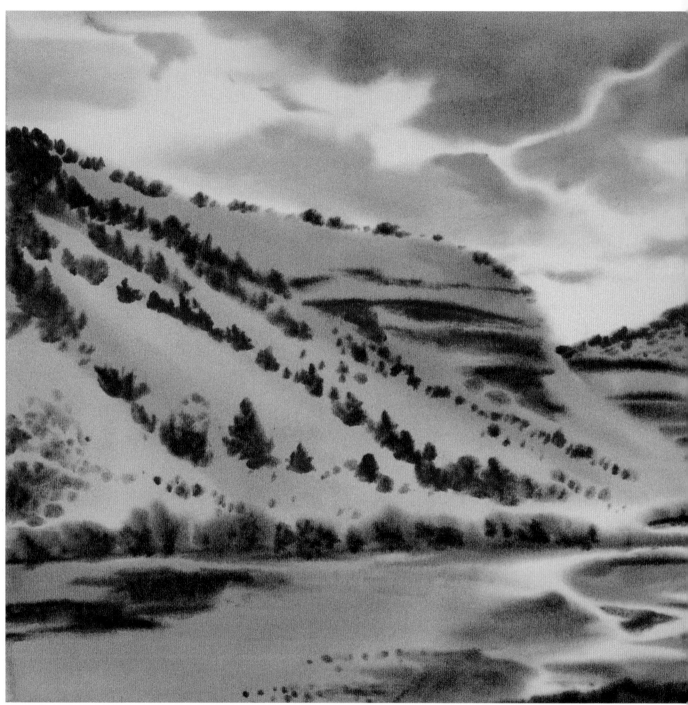

Chama River—Snow by Julia Jordan. Transparent watercolor on d'Arches 140 lb. cold-pressed paper, 22 × 30" (56 × 76 cm). Collection of Sue and Doug Laird.

This painting has no crisp edges, but only soft, shapely marks. It was painted very quickly while the paper was soaking wet. Lighter areas were painted with thin paint on a nearly dry brush, and darker areas were painted with tube-thick paint.

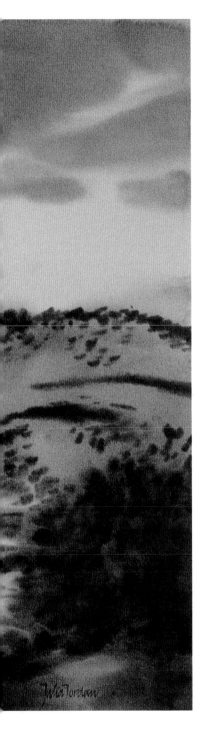

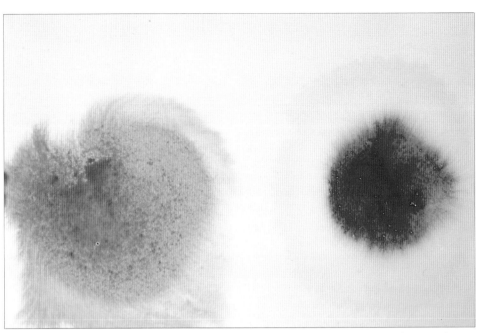

This photo shows how watercolor, on the left, spreads out more on wet paper than acrylic. The brushloads of paint were about equally thick, but the acrylic has more of a tendency to stay put.

An airbrush can be useful to rewet an area on a watercolor without disturbing the dried pigment already on the paper.

CRISP EDGES

If you want one crisp edge and one soft edge on a stroke using the prewet approach, slightly overlap the paint stroke onto dry paper on the side to be crisp, with the bulk of the stroke on the prewet area. The dry paper on the sharp-edged side will resist the moisture in the stroke long enough to create a clean line there.

By the same token, any stroke on dry paper will have a crisp edge, whether the paper is still white or has been previously painted. To be sure a previously painted area is dry enough to be overpainted with crisp strokes, touch the back of a finger (less oily than the front) to the wash. If the paper is cool, it is not quite dry.

BLOOMS

As mentioned above, if a wash is partially dry, and a comparatively greater wetness is introduced into it, a bloom will result. The effect will be the same whether the greater wetness is introduced with a brush,

accidentally dropped water, water flowing into the wash from an adjacent wetter wash, water that has accumulated around staples at the edge of the paper, or water flowing downhill. As the damp wash sucks up moisture from this greater wetness source, pigment in the wash is pushed aside and accumulates at the edge of the resulting bloom, like seafoam washed up on a beach.

A bloom is usually undesirable, an unplanned interference with your painterly intentions. However, the principle for bloom-making can be intentionally applied to create marks that look like stars, or pale trees against a dark sky, or whatever your imagination dictates. The important thing is to be in control by understanding the principle and how to prevent its action or use it to your advantage.

Because watercolor takes longer than acrylic to set up, it is susceptible to blooms for a longer time, until the wash is completely dry. A partially dry acrylic wash often resists blooms, on the other hand.

Watercolor (left) and acrylic (right) behave the same when you want crisp marks on dry paper.

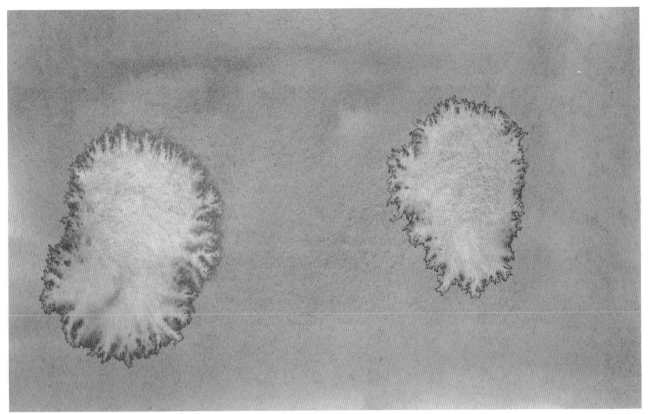

The edge and size of the bloom will vary depending on how wet the paper is when the water drop hits it. The bloom on the right, made when the paper had dried past the shiny point, has a slightly harder edge than the larger bloom on the left, made with the same amount of water while the wash was still shiny wet.

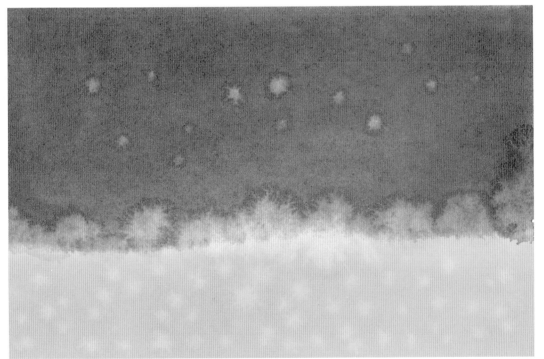

Blooms can be used intentionally to depict such things as stars in the sky, light foliage against a dark background, or dandelions in the grass.

LARGE, SMOOTH WASHES

Large washes are perhaps the trickiest aspect of water media painting, because of the tendency of a large painted area to dry at an uneven rate, causing backruns and blotches by capillary attraction. If the wash is meant to be even (or evenly graded, as in painting a clear sky), any imperfections in its execution will be glaringly obvious to the viewer, and corrections are often impractical, as when the first wash *is* the final wash.

There are two time-tested methods of controlling a large wash. The most traditional is called "running a bead." This method uses both gravity and capillary attraction to create a smooth wash, though it works only in relatively high humidity. Tilt the painting surface and make your first stroke at the top of the area to be painted, with a *fully* loaded brush. Gravity causes a bead of paint to form at the bottom of the stroke, where the dry paper below resists the invasion of the wet mark. Quickly refill your brush with another full load, and stroke it just below the first mark, overlapping slightly, and pulling the bead of paint down the page by another brush width. If you want to change hue or value, more or less water or different pigments may be introduced as the strokes proceed down the wash. When the wash is complete, pick up the remaining bead with a thirsty brush, and keep the painting

Slanting the painting board causes gravity to form a bead of pigment that the artist drags down the page with successive horizontal strokes of the brush. This technique is called "running a bead."

The beaded wash, completed. I had intended to illustrate how a ridgy-looking wash results from this technique in my dry home state of New Mexico. However, the week these demonstrations were photographed turned out to be rainy and unusually humid, so this is how a beaded wash is supposed to look. Do bear in mind that if humidity is below 50 percent, prewetting produces more reliably smooth washes.

This is a beaded wash painted on a drier day (humidity 30 percent), which shows the ridginess that can result when the bead begins to set during the painting of the wash.

surface tilted until the wash is dry, so that gravity can counteract the tendency of the wetter strokes at the bottom to invade the damper ones above. (A hair dryer can help here.)

The reason this method, invented in the damps of England, does not work in low humidity is that the pigment in the bead will begin to set before the next stroke can be made, causing the resulting wash to look ridgy. And because of acrylic's quicker setting time, it is difficult or impossible to make a smooth acrylic wash by running a bead, no matter how humid the weather.

An alternative method of making a smooth wash is to prewet the entire area and quickly paint in the color. Prewetting evens out the distribution of pigment as you stroke in color, and gives you more time to work the wash. This is actually a variation of the wet-in-wet approach described earlier. For acrylic, or in a dry climate, prewetting is the easiest way to make a smooth wash.

If, for any reason, there are any unwanted irregularities in an acrylic wash, or if you want it darker or an altered hue, glazing will smooth out the color without dulling the paint quality. With watercolor, the most beautiful washes are accomplished on the first try; going over them usually doesn't make them better.

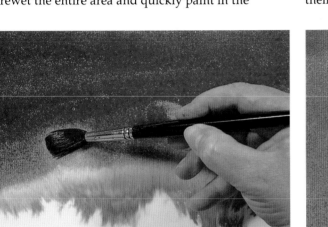

A large, even wash can be painted by prewetting the paper with clear water. The water pulls the pigment around on the paper, spreading it evenly.

The prewet wash, completed.

A prewet wash at 30 percent humidity.

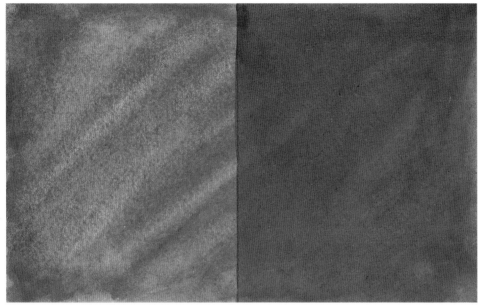

This illustration shows an uneven acrylic wash that has been glazed over once, on the right side, evening out the color somewhat.

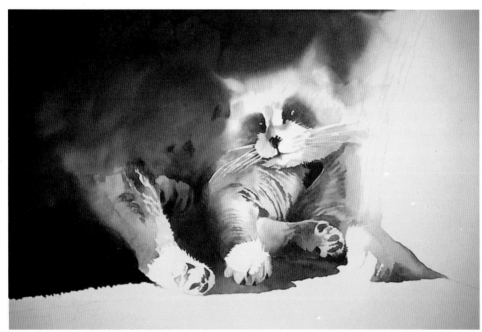

This and the following illustrations demonstrate an exception to the rule that a watercolor wash is seldom improved by going over it. I was displeased by the uneven quality of the background wash in this painting in progress, caused by stroking into a drying area with a wetter brush. The wash was also not dark enough to satisfy me.

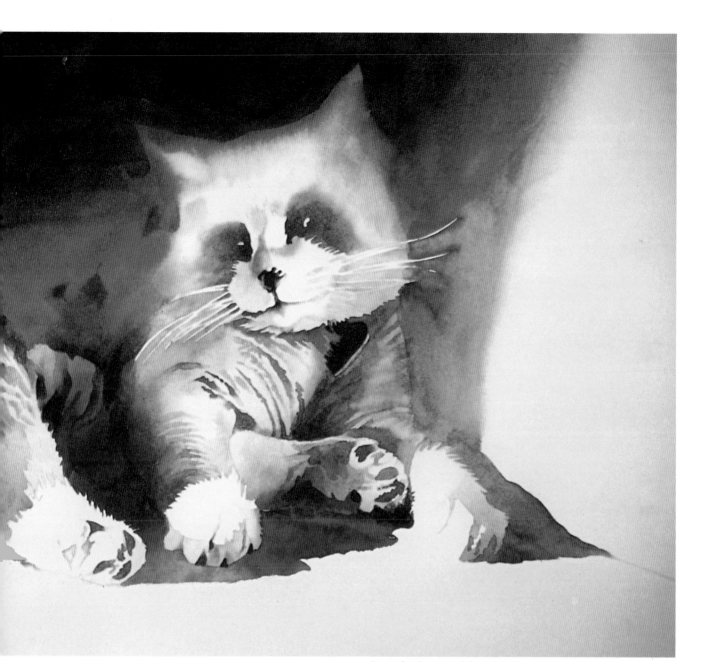

Once the first wash had dried completely, I worked very quickly to cover it with a second wash, which I extended out to the right-hand edge of the shadow area, lightening as I went along by diluting the puddle of paint on my palette. The result was a smoother, darker wash than the first attempt, which did not become muddy because I didn't stroke over any area more than once.

BRUSHWORK

Here we will explore the use of brushes to create desired effects and avoid hateful ones. Let us think for a moment about brushes as tools. As children we learned how to hold and use pencils and crayons and ballpoint pens: All are gripped similarly, and similarly applied to paper to make a mark. Those of us old enough to have been taught to use a straight pen or fountain pen learned a slightly different concept of touch, based on the fact that applying the same amount of pressure to a nib as you would to a pencil results in the destruction of the nib. Now comes the brush, a whole different breed of mark-making implement. Zen monks may spend years practicing the proper holding and manipulation of a brush before being considered skilled in its use. Why should we water media painters assume we can master brushwork without a similar effort?

HOLDING THE BRUSH

Many painters recommend a grip on the brush that seems unnaturally high on the handle at first, accustomed as we are to holding pens and pencils. I think this grip is something we must grow into, for what the beginning painter seeks first of all is *control*. You will find in general that the more detailed the

A high grip is conducive to broad, spontaneous strokes.

Holding the brush like a pencil allows more control and is preferable for fine strokes.

painting, or the smaller the strokes, the closer to the brush hairs you will want to grip the brush. Thus, holding a brush higher up the handle encourages looser, broader, freer strokes. If you aspire to free, confident-looking strokes, it is worthwhile to practice holding the brush higher.

When you hold the brush high on the handle for a free-swinging stroke, it is natural to use your whole arm. In writing with a pencil, you rest the side of your hand on the table, and this allows maximum control of the mark. Moving from this position of utmost control toward one allowing ever greater spontaneity, you eventually stand up, which allows the arm to move freely. The most spontaneous strokes will engage the shoulder, and the whole body will sway with the motion. This is why it is best to stand while sketching, while painting large areas, or while adding spontaneous marks to a piece. For precision, it is better to sit.

THE BRUSHSTROKE

With a painter's very first brushstroke comes the discovery that the touch required is different from that required for any other mark-making instrument. Many new painters respond to this challenge by overcompensating: Rather than risk mashing the

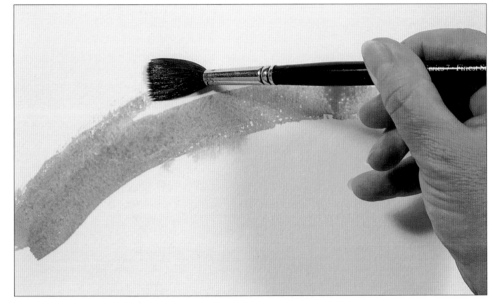

Here is a spontaneous stroke, using a high grip and the whole brush.

SLOW STROKE

FAST STROKE

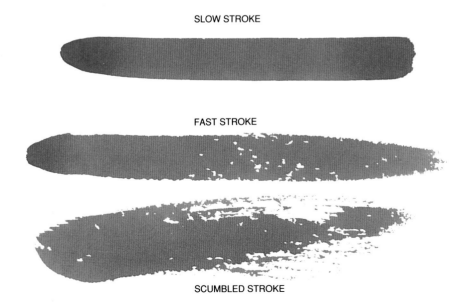

SCUMBLED STROKE

A slow stroke, pulling the brush hairs parallel to the direction of the stroke, produces a crisp, solid mark. A fast stroke has rougher edges and skips along the top of the paper's texture, leaving white spots. A scumbled stroke is fast and skids sideways along the paper. Each kind of stroke has uses in painting.

brush down, they tickle the paper with its tip. Yet, in failing to use the entire brush, they lose an important advantage of painting over drawing: the ability to make a thick, rich stroke, and to cover the painting surface quickly (thus, more spontaneously) with color. Some artists just naturally have a strong preference, or even a need, for complete control over the marks they make; such artists might be happier painting with pastels (for an opaque effect) or colored pencil (for a transparent effect that often looks very much like watercolor from a distance). If *painting* is your goal, one very important step is training yourself to use the whole brush.

In the foregoing pages there has been frequent mention of a loaded brush. What, exactly, does this mean? A loaded brush is one that contains as much water and pigment as it can hold without dripping. If it *is* dripping, there is danger to the painting, and controlled brushwork is impossible. To remove just enough water and pigment to make the load manageable, touch the hairs *near the ferrule* to something absorbent. I keep a folded piece of flannel or old floursack toweling next to my water container for this purpose. By pressing the brush against this cloth near the ferrule, I am extracting mostly water from the load, rather than losing pigment.

Perhaps because a loaded brush is so close to being an out-of-control brush, relatively inexperienced painters have a strong tendency to underload. They dip only the very tip of their brush in paint and apply it to the paper. Dip. Paint. Dip. Paint. The result is a dry and lifeless-looking image. I think the only way to overcome this habit is to practice strokes with a loaded brush until it feels comfortable. Even an hour or two of stroking practice could change forever the way you paint, leading to a breakthrough in painting skill. At the same time you can practice using the whole brush and engaging your whole body in the motion of the brushstroke.

The beginning of this chapter went into some detail about achieving certain kinds of edges in painting marks, based on the relative wetness of paint and paper. The quality of a mark also depends on the way the brush is handled. For example, to make a mark with clean, crisp edges, you need not only wet paint and dry paper, but a slow stroke. A fast stroke creates rough edges. Furthermore, you must hold the brush so that the hairs are pulled down the stroke rather than across it; in other words, the hairs of the brush should lie parallel to the edge of the mark while the stroke is being made. This could be compared to driving a car in the direction the wheels are turned as opposed to skidding sideways.

Conversely, a rough stroke, or scumble, can be made by turning the rules for a crisp stroke on their head: Use thicker paint, or a relatively dry brush, and rapidly drag the brush sideways across the paper.

The rules about brushwork apply equally to watercolor and acrylic.

To remove excess moisture from a brushload, press the brush near the ferrule against an absorbent cloth.

TEXTURES

There are ways of manipulating paint on paper that do not involve a brush, and many of these are useful for representing textures. However, there is a danger in relying too routinely on such methods, lest they be reduced to gimmicks. When used thoughtfully in the context of the work, textural techniques should not cry out to be noticed, but contribute to the overall harmony, wholeness, and radiance of the piece (these being Aquinas' criteria for beauty).

SALT

Salt has the quality of seeking to bond with water. Sprinkled on a wet painting, each grain will suck up the water and pigment in its immediate vicinity, creating a little island of pale paper around itself. The size of the island and the quality of its edge will vary according to the size of the grain of salt and the wetness of the water/pigment mixture on the paper. The wetter the wash and the bigger the salt grain, the bigger the pale island it will create. Conversely, if the paint is fairly thick or dry, sprinkling salt on it will only make for a gritty painting surface.

Using salt on a painting is a little hazardous. Just as the islands it makes look somewhat like blooms, salt shares the habit blooms have of sneaking up on the painter with unpleasant surprises. Its effects are also not immediately apparent and cannot be hurried. Like a watched pot, the salted painting seems never to produce the intended result until you give up and walk away from it. The effect appears only when the area has completely dried, and using the hair dryer actually interferes with the process.

Another hazard of salt is its potential chemical effect. It is not really known how salt may interact with pigments, mediums, and paper over time, but conservationists generally warn against introducing any "polluting" element into the painting process.

Having duly presented you with all these caveats, I must confess that occasionally only salt will create the effect you desire—for example, the illusion of a field studded with dandelions in seed, or a mottled surface with just the right feeling of spontaneity.

Before you can use salt, the painting surface must be at least shiny wet, and at the most, swimming with water and pigment. It is best to experiment on scrap paper before using salt on a painting in progress, to get the feel of its effect with varying degrees of wetness. Allow the wash to dry completely, and then brush off the salt. It is a good idea to clear the entire painting area of stray grains of salt, which could find their way back onto the painting and cause unplanned effects.

Table salt hardly ever has enough effect to be noticeable because the grains are so small. For a larger-grained salt, try kosher salt or margarita salt (available in the liquor department of the grocery store).

This texture was created by sprinkling margarita salt on wet paint.

Harvest Mandala by Julia Jordan. Transparent watercolor on d'Arches 140 lb. cold-pressed paper, 22 × 30" (56 × 76 cm). Collection of Dr. Paul Glatleider.

Silverton by Julia Jordan. Transparent watercolor on d'Arches 140 lb. cold-pressed paper, 22 × 30" (56 × 76 cm). Collection of the artist.

Salt was successfully used in the foreground of this painting to create the effect of dandelions in the grass. The use of salt in the background, to suggest trees on a mountainside, is less satisfying.

I used salt to liven up the background of this painting, and I think the textural trick succeeds in this context.

The use of plastic wrap and wax paper has been demonstrated at so many watercolor workshops in recent years that every watercolor show seems to be loaded with examples of its use. Yet, in my perception, there are relatively few kinds of subject matter that lend themselves to this technique with integrity. It is frequently used to represent a cliff, a rocky bank, or a semiabstract landscape. To avoid the production of a visual cliche, use this technique with extreme thoughtfulness.

The effect of kitchen wraps is created in an inverse manner from the effect of salt. Wet paint is attracted to the material touching the paper's surface and dries in concentration at the point of contact. To create the effect, crumple waxed paper or plastic wrap and press it onto a wet wash. The richer the pigment concentration in the wash, the more pronounced will be the marks produced, as long as the paint is shiny wet when the wrap is applied. Again, natural drying is required before you can proceed with the painting. When the paint has dried thoroughly, peel off the wrap, and voila!

Plastic wrap pressed into wet paint. After the paint has dried and the plastic wrap is removed, this is the result. The triangular shapes are very characteristic of this technique.

Waxed paper pressed into wet paint. The shapes formed by the interaction of the waxed paper and the paint are more rounded, less identifiable than those formed with the plastic wrap.

Sponges, especially natural sponges, can be used to create interesting, varied textures that resemble rock surfaces, bumpy ground, trees and foliage, or whatever your imagination dictates. A damp sponge can be used to apply paint, or a clean damp sponge can be used to lift off color (damp or dry watercolor or damp acrylic). This is done by pressing the sponge to the paper, without any wiping motion. Perhaps a little wiggle, while pressing gently on the sponge, helps when lifting off.

Various materials may be used to imprint textures on watercolor paper. For example, Japanese rice paper is made in a variety of patterns. Pieces of such paper can be pressed into a damp wash, or rolled with a brayer, to lift off a negative imprint. Or they may be painted and pressed onto the painting to add a positive imprint. Cheesecloth, netting, and lace can be used the same way. I have found a loofah useful to imprint weedy textures. A crumpled tissue or paper towel, pressed into a wet wash, gives a wrinkled texture. The

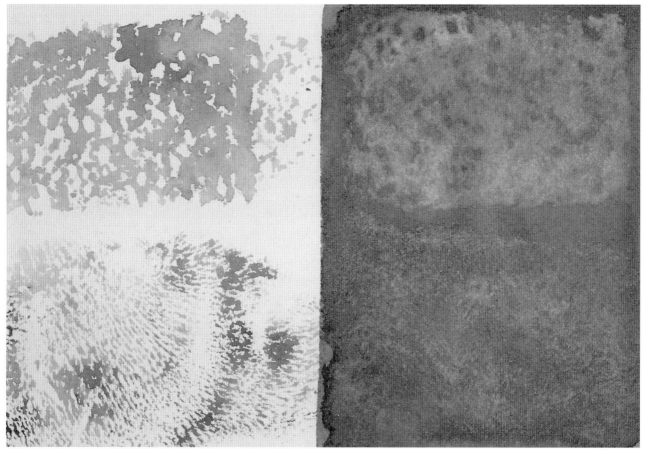

On the left are sponge prints, the upper print made with a large-pored sponge, the lower one with a sponge of finer grain. The sponges were dipped into wet paint and then pressed onto the paper. On the right, the same sponges, clean and damp, were used to lift off a different kind of

pattern. The first kind of image is called positive because you see color where the sponge touched; the second kind is a negative image because you see color where the sponge did not touch—the image on the paper is that of the gaps in the sponge's surface.

possibilities are limited only by your imagination. The process works best, however, if the material is absorbent enough to hold at least a little paint without dripping or puddling.

WATER SPRAY

I always have a spray bottle full of water at my right hand to dampen my paints from time to time, but it is also useful for creating textures on occasion. A shot of water spray can help create an illusion of tangled foliage when directed to an area of damp or wet paint. It tends to create little rivulets that carry pigment beyond the previously painted area. Juicy paint may also be dropped into an area sprayed with clean water, and it will spread in the same way. This is a technique that demands experimentation before being tried on a real painting.

Patterned rice paper laid on a damp wash can create an interesting negative pattern. A brayer is useful for evenly pressing the paper into the wash. At right, the impression left by the rice paper.

Printing with a loofah.

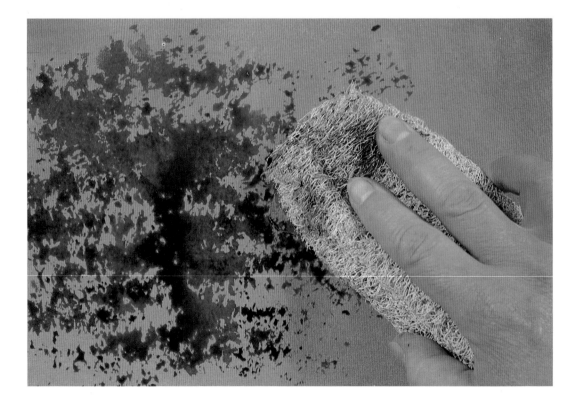

Using crumpled tissue to lift off a textural mark.

Water spray can be directed at paint already on the paper, or paint can be dropped into a sprayed area. Mixing colors on a sprayed surface can produce especially interesting effects.

MIXING PAINTS AND COLORS

The first mixing you do when setting out to paint is to add water to pigment. It is very useful and thrifty to have a small spouted bottle for this purpose. With it, you can add one or two drops of water to a glob of paint, or several tablespoons. This is much more efficient than adding water with a paintbrush, which wastes paint every time the brush is dipped in the water pot, and makes the water dirty as well.

The amount of water to add is dictated by the kind of stroke or wash intended, but you must add at least enough water to allow the brush to penetrate the pigment and absorb it. To see what I mean, try inserting a soft watercolor brush in a glob of paint straight from the tube or jar. Most of the time the brush will bend, not penetrating the glob of paint very far, and painting with it is nearly impossible, like shoving a wet noodle up the wall. If you want to apply really thick paint, a bristle brush or stiff synthetic designed for acrylic on canvas is appropriate. To put it another way, we use soft brushes in transparent painting because they work best with thin paint.

When you are painting a very pale wash—that is, one where the proportion of water to pigment is very high—the medium holding the pigment particles together may become so diluted that the paint will not adhere well to the paper. The pigment particles may become almost a dust (like pastel dust) when the wash dries. You can strengthen the wash without intensifying the color by adding gum arabic (also labeled watercolor medium) to watercolor, or matte acrylic medium to

acrylic, while it is being mixed with water. "A little dab'll do ya."

Watercolor and acrylic behave very similarly when being mixed with water on the palette, but acrylic will absorb more water proportionate to pigment.

MIXING COLOR

It seems we all learned as children that blue and yellow make green, and yellow and red make orange, but beyond that many new painters seem to find color and color mixing mysterious and baffling. Adding to the confusion is the plethora of appealing colors available in color charts and art supply stores. Teachers and books tout idiosyncratic favorites that may be purchased out of enthusiasm for the work of the teacher, and gradually the painting student accumulates a large collection of paint tubes, many of which dry out before they can be used up.

This section will not discuss all the various pigments available, simply because there are so many, and few artists can claim familiarity with all of them. Rather, I will attempt to outline some of the salient characteristics and uses of some watercolor and acrylic pigments I do know well, which can act as signposts in evaluating others that are not mentioned here.

While some pigments are used in both watercolor and acrylic (such as cobalt blue and phthalo blue), there are also some differences (for example, alizarin crimson in watercolor is replaced by quinacridone crimson in

Diluting paint on the palette using a spouted bottle.

acrylic). The effect of acrylic medium on pigments makes them *all* staining and permanent, and enhances their transparency. In watercolor, on the other hand, whether a pigment is staining or nonstaining, transparent or opaque, is a relevant consideration. The specific qualities of pigments in each medium are explored in the next few pages, beginning with watercolor, then going on to acrylic.

WATERCOLOR: STAINING AND NONSTAINING PIGMENTS

I once had a conversation with a Winsor & Newton spokesman who informed me that *all* pigments are staining, in the sense that the wet pigment penetrates the watercolor paper and can never be completely washed out. In art, however, appearance is everything, and for practical purposes we say a pigment is nonstaining when its visible effects can be washed from the surface of the paper to a reasonable extent. When we talk of nonstaining colors, then, the term is used in a relative sense: Compared to staining colors, they may be removed more easily from the paper.

The pigment that is most nonstaining by this definition is manganese blue. After lifting it off, you can generally return to an appearance of nearly white paper.

The next most easily removed is rose madder genuine. This pigment could have a fascinating book written about it, if Winsor & Newton didn't consider most of its story top secret. I have been able to learn only that its source, the madder root, is available exclusively from some country in the Middle East, and that local turmoil and other considerations often interfere with its availability. The extremely complex, exacting, and lengthy manufacturing process is also secret, and only Winsor & Newton makes it. From time to time this pigment, which is always quite expensive, is impossible to find. Other purveyors of pigments sell a rose madder that is *not* a nonstaining pigment and is probably akin to alizarin crimson, which was developed by Winsor & Newton in the nineteenth century as a less expensive substitute for rose madder genuine. (More on alizarin below.)

The only nonstaining yellow is aureolin, which unfortunately is not a very pretty yellow because of its rather greenish cast. But aureolin profits from a dab of rose madder genuine to warm it up. The earth colors—sienna (burnt and raw), ochre, and umber (burnt and raw)—are relatively nonstaining.

A very useful nonstaining blue, which is closer to a true blue than manganese, is cobalt blue. Cerulean blue is relatively nonstaining, but not so much as its close neighbor in hue, manganese blue. Ultramarine blue is a red-blue, somewhat deeper than cobalt, and relatively nonstaining. (The original ultramarine was made from ground lapis lazuli and was so precious that only painters with wealthy patrons could afford to use it, and then it was generally reserved to paint the robes of the Virgin Mary. The pigment we buy today is an approximation.)

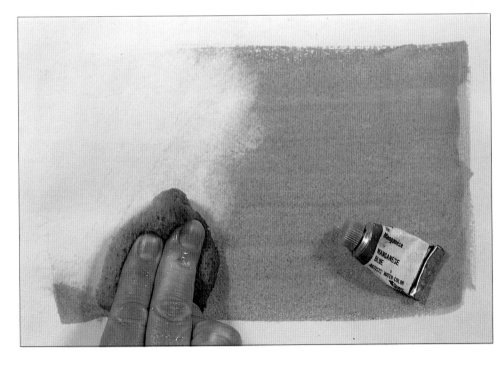

Manganese blue is the least staining watercolor pigment. Here a dried wash of this pigment is washed off nearly completely with a clean, damp sponge.

The most intensely staining watercolor pigment is phthalo (or thalo) blue and its green and purple relatives. What this implies is that a drop of phthalo blue where you don't want it is a screaming headache. On the other hand, it's a great color for painting sky, because if, after it has dried, you drop water on it accidentally and wipe it off right away, you can almost get away with it. This paint is there to *stay*.

Staining reds include alizarin and cadmium, and yellows that stain are cadmium and new gamboge.

TRANSPARENCY

When a transparent pigment is painted over a dry wash, it allows the underlying layer of color and the glow of the paper beneath to shine through. By contrast, an opaque (sometimes called sedimentary) pigment will have more covering power.

The quality of transparency is, of course, what this book is about, and it won't be a surprise that I prefer transparent pigments over more opaque ones. Sometimes I'm willing to sacrifice purity of hue in favor of transparency, if I can't have both. Thus, I never use cadmium yellow, which is the most beautiful true yellow, because of its opacity and the fact that, when mixed with other pigments, it creates a muddy wash. Instead, I choose aureolin yellow or new gamboge. (Aureolin, as mentioned above, tends toward green, and new gamboge tends toward orange. Gamboge hue, on the other hand, is greenish rather than orangish, and seems totally unrelated in hue to its stepchild.)

The truest red is cadmium red, which is as opaque as its yellow sister, and mixes as poorly. I do keep a small tube of cadmium red handy for those occasions when a spot of pure, true red is called for. The sheerest red is rose madder genuine, followed by its imitator, alizarin crimson. These reds tend toward the blue rather than being true, but can be effectively warmed up with a touch of yellow.

In the blues, cobalt and phthalo are both transparent, as is manganese. Ultramarine is quasi-transparent, and cerulean is downright opaque.

The earth colors are also moderately transparent, except for yellow ochre, which is opaque.

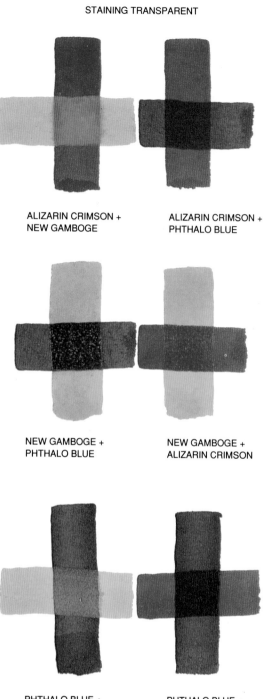

STAINING TRANSPARENT

ALIZARIN CRIMSON +
NEW GAMBOGE

ALIZARIN CRIMSON +
PHTHALO BLUE

NEW GAMBOGE +
PHTHALO BLUE

NEW GAMBOGE +
ALIZARIN CRIMSON

PHTHALO BLUE +
NEW GAMBOGE

PHTHALO BLUE +
ALIZARIN CRIMSON

This chart compares how transparent staining, transparent nonstaining, and opaque pigments behave when one pigment is painted over another. Clearly, opacity does not prevent the underlying stroke from being visible through the overstroke. Rather, there is a subtle difference in the appearance of the pigment on the paper. This is especially apparent when opaque pigments are mixed, as opposed to being used in the pure form, as here.

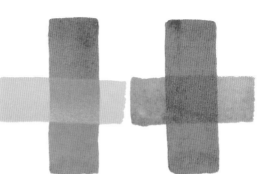

ROSE MADDER GENUINE +
AUREOLIN YELLOW

ROSE MADDER GENUINE +
COBALT BLUE

CADMIUM RED +
CADMIUM YELLOW

CADMIUM RED +
CERULEAN BLUE

AUREOLIN YELLOW +
COBALT BLUE

AUREOLIN YELLOW +
ROSE MADDER GENUINE

CADMIUM YELLOW +
CADMIUM RED

CADMIUM YELLOW +
CERULEAN BLUE

COBALT BLUE +
AUREOLIN YELLOW

COBALT BLUE +
ROSE MADDER GENUINE

CERULEAN BLUE +
CADMIUM YELLOW

CERULEAN BLUE +
CADMIUM RED

TINTING STRENGTH

This term refers to the amount of "bang for the buck" you get with different pigments—that is, how much pigment you need (in proportion to water) to arrive at comparably intense washes. Another test of tinting strength is how much of each pigment you use when mixing to reach an approximately balanced blend of hue. For example, if you want to mix rose madder genuine and new gamboge for a true orange, you must use quite a bit of rose madder genuine and only a tiny amount of new gamboge. This is because rose madder genuine has a low tinting strength (which, incidentally, adds considerably to the expense of using it), and new gamboge has a lot of strength. The strongest of the pigments is phthalo blue, followed by alizarin crimson. Among the weakest (with rose madder genuine heading the list) are manganese blue and the earth colors. Tinting strength is best determined by experimenting with mixing the various pigments on your palette. It is mentioned here just to alert you to this consideration.

GRAININESS

Some pigments have a tendency to dry with a grainy quality, especially when mixed with others. Personally, I almost always find this result appealing, but I know some artists do not, and sometimes it isn't appropriate to the piece. The pigments that are most inclined to be grainy, in descending order, are: manganese blue, rose madder genuine, ultramarine blue, and cobalt blue. The smoothest washes can be made with phthalo blue, alizarin, or new gamboge.

HUE

I have discussed hue in connection with other pigment characteristics, in order to see how tradeoffs are sometimes made. The color wheel at right arranges these pigments to show which ones are the most "true", and which tend toward a neighboring primary color.

The color wheel also illustrates why red, yellow, and blue are considered primary colors: All other colors derive from them. Secondary colors are, thus, those mixed from two primaries: orange, green, and purple.

A grainy wash, composed of ultramarine blue and manganese blue, is juxtaposed with a comparatively smooth wash on the right, painted with the staining pigment phthalo blue.

PRIMARY
HANSA YELLOW
MEDIUM (ACRYLIC)

NEW GAMBOGE
(WATERCOLOR)

AUREOLIN
YELLOW
(WATERCOLOR)

QUINACRIDONE
GOLD (ACRYLIC)

YELLOW +
PURPLE

SECONDARY
QUINACRIDONE
RED + HANSA
YELLOW (ACRYLIC)

GRAY FROM
YELLOW +
PURPLE

SECONDARY
PHTHALO BLUE +
HANSA YELLOW
(ACRYLIC)

ORANGE +
BLUE

GREEN +
RED

GRAY FROM
ORANGE +
BLUE

QUINACRIDONE
CRIMSON +
PHTHALO BLUE +
QUINACRIDONE GOLD

RAW UMBER
FROM
GREEN +
RED

MANGANESE BLUE
(WATERCOLOR)

BROWN
FROM RED +
GREEN

GRAY FROM
BLUE +
ORANGE

RED +
GREEN

BLUE +
ORANGE

PHTHALO BLUE
(ACRYLIC OR
WATERCOLOR)

PRIMARY
CADMIUM
RED MEDIUM
(ACRYLIC OR
WATERCOLOR)

GRAY FROM
PURPLE +
YELLOW

PRIMARY
COBALT BLUE
(ACRYLIC OR
WATERCOLOR)

QUINACRIDONE
RED (ACRYLIC)

ROSE MADDER
GENUINE
(WATERCOLOR)

PURPLE +
YELLOW

ULTRAMARINE BLUE
(WATERCOLOR)

QUINACRIDONE
CRIMSON (ACRYLIC)

ALIZARIN CRIMSON
(WATERCOLOR)

OPERA
(WATERCOLOR)

SECONDARY
COBALT BLUE +
QUINACRIDONE
RED (ACRYLIC)

The color wheel, showing the relationships of pure pigments and mixtures. The three primary hues—yellow, red, and blue—are represented by pigments that approach primary purity. The secondary hues—orange, green, and purple—are mixed from the primary hues closest to them on the circumference of the circle.

Other hues mentioned in this text are arranged on the circumference to indicate where they fall in relation to neighboring hues. For example, ultramarine blue, a purplish blue, is placed closer to purple on the wheel, while phthalo blue, a greenish blue, is placed closer to green. The four red pigments to the right of cadmium red are all purplish red to about the same degree, so their order is arbitrary. Opera is the most purplish red.

The color spots inside the circle show the relationships between complementary colors on opposite sides of the circle. Adding a complement to a primary grays it; theoretically, equal mixtures of complementary colors make gray or black.

COMPLEMENTARY COLORS

Looking again at the color wheel, notice the hues that fall opposite each other on the wheel. These are called complementary colors. I'm not sure why, because they don't seem to complement each other; on the contrary, when placed next to each other, complementary colors seem to jump, clash, vibrate. Their juxtaposition is exciting, almost disturbing, to the eye. In painting, if one area juxtaposes complementary colors, the viewer's eye tends to become riveted on that spot. Therefore, if you want to direct the viewer's attention to a certain place on a piece (usually called the center of interest), one trick is to place complementary colors next to each other there: blue and orange, red and green, yellow and purple. Bang! On the other hand, careless placement of complementary colors where you do *not* particularly want the viewer's eye to stray is merely distracting. (To create tension, put complementary colors in one center of interest and some other irresistible eye-catcher, such as a human face, in another.)

COLOR MIXING

Looking again at the color wheel, we can see that by mixing primary colors that are adjacent on the wheel, we arrive at the secondary colors that lie between them. By mixing colors that lie on opposite sides of the wheel, we achieve the neutral colors found in the center of the circle: gray, black, brown.

Still, we must realize that the color wheel is a theoretical construct, based on the physics of what happens when white light is split into a spectrum of pure colors. When we use pigments we are only attempting to approximate the spectrum, and sometimes the results don't even seem close.

Green: I mention green first because this seems to be a very troublesome color in painting. Viewers often seem to reject paintings with a lot of green in them, and I've had galleries turn down a painting because it had "too much" green. Apart from this esthetic mystery, artists also struggle to paint greens that appear natural (especially with reference to landscapes). Here an important insight attributable to Texas painter Naomi Brotherton is: Nature's green contains red. What that really means is that the green in nature differs from the green that comes out of a tube in being grayer, because by mixing it with the color that falls across from green on the color wheel, red, we *gray* the green.

There are many greens available from pigment makers, and you may have noticed that I haven't mentioned any of them above. After buying a variety of tube greens, I found they would dry up before I could use them up. It's more economical, and not at all difficult, to mix any green you might need from the primary colors.

Orange: Orange is *so* easy. Aureolin and rose madder genuine, new gamboge and alizarin, even cadmium red and cadmium yellow make wonderful oranges. Cadmium orange from the tube is a fabulous color, and it might be worth it to keep a small tube on hand for those rare moments when only a touch of cadmium orange will do (but I've gotten along without it for years). To make a dusty orange, or a grayed orange, add a little of the complement, blue (cobalt is purest).

Purple: From lavender to maroon, purple is a combination of red and blue, though maroon has a little yellow to warm it up. For most of the uses of purple,

Juxtaposing complementary colors causes excitement to the eye.

GREEN + RED

BLUE + ORANGE

PURPLE + YELLOW

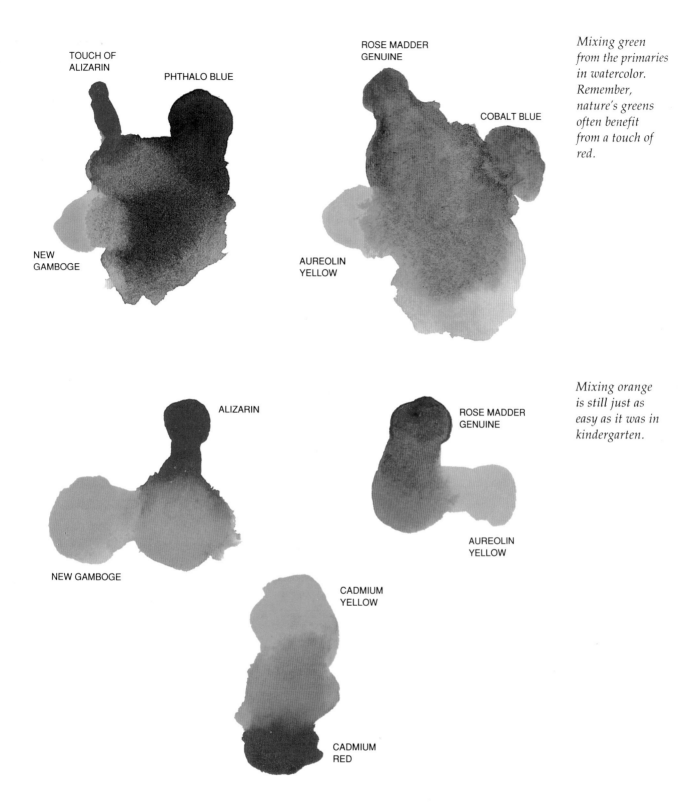

TOUCH OF
ALIZARIN

PHTHALO BLUE

NEW
GAMBOGE

ROSE MADDER
GENUINE

COBALT BLUE

AUREOLIN
YELLOW

*Mixing green
from the primaries
in watercolor.
Remember,
nature's greens
often benefit
from a touch of
red.*

ALIZARIN

NEW GAMBOGE

ROSE MADDER
GENUINE

AUREOLIN
YELLOW

*Mixing orange
is still just as
easy as it was in
kindergarten.*

CADMIUM
YELLOW

CADMIUM
RED

mixing red and blue produces acceptable results, with the exception of painting flowers. The brilliant, clean color of certain purple and purple-red flowers seems best approached with two tube colors I know of: Winsor & Newton's cobalt violet (*very* expensive), and Holbein's opera.

Gray: Many people think of gray as pale black, and indeed it is possible to make gray by diluting black paint or india ink. However, the liveliest grays, varying from warm to cool, are mixed from the three primary colors. Sometimes very interesting effects are created by actually mixing the grays on the paper, by painting first a clear water wash, then dropping fairly juicy brushloads of the primaries into the puddle and allowing them to blend. The transparent, grainy, nonstaining primaries (aureolin, rose madder genuine, and cobalt blue) create the tenderest grays.

Black: As child artists, I think we all would have considered our sets of crayons or watercolors upsettingly incomplete without a black. I seem to recall serious kindergarten battles over the only black crayon at the table. How, then, can a watercolorist paint without a tube of black paint? Of course, there are black pigments on the market, but they seem somewhat dead and stark when combined with other colors in a transparent painting. To mix black, a combination of the three primaries can be very convincing. As Barbara Nechis once said with stunning simplicity, "To mix a dark, combine dark colors." Therefore, to approach black, select the most intense or dark of the primary pigments; among those mentioned above, these are phthalo blue, alizarin crimson, and new gamboge. Like gray, "black" can range from warm to cool. To warm it,

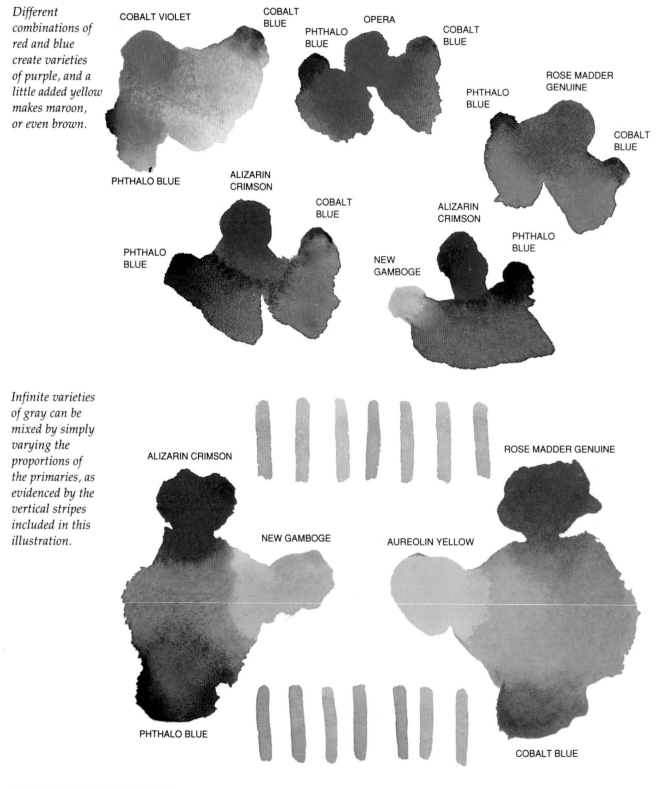

Different combinations of red and blue create varieties of purple, and a little added yellow makes maroon, or even brown.

COBALT VIOLET

COBALT BLUE

OPERA

PHTHALO BLUE

COBALT BLUE

PHTHALO BLUE

ROSE MADDER GENUINE

COBALT BLUE

PHTHALO BLUE

ALIZARIN CRIMSON

COBALT BLUE

PHTHALO BLUE

ALIZARIN CRIMSON

PHTHALO BLUE

NEW GAMBOGE

Infinite varieties of gray can be mixed by simply varying the proportions of the primaries, as evidenced by the vertical stripes included in this illustration.

ALIZARIN CRIMSON

ROSE MADDER GENUINE

NEW GAMBOGE

AUREOLIN YELLOW

PHTHALO BLUE

COBALT BLUE

add more yellow and red. To cool it, add more blue. To deaden it, add more yellow.

Brown: This is merely a different proportion of the three primaries. Think about mixing green and red, a trick someone taught me once. But since green is a mix of blue and yellow, green and red is actually our old primary combo.

Mixing paints on the paper rather than on the palette, as mentioned in the "Gray" section, applies to mixed colors in general, and is appropriate whenever a smooth, pure wash is not called for. Another option is to mix paints on the brush, dipping it sequentially into the various paints and then applying it directly to the paper. Both these techniques can produce interesting effects without sacrificing realism.

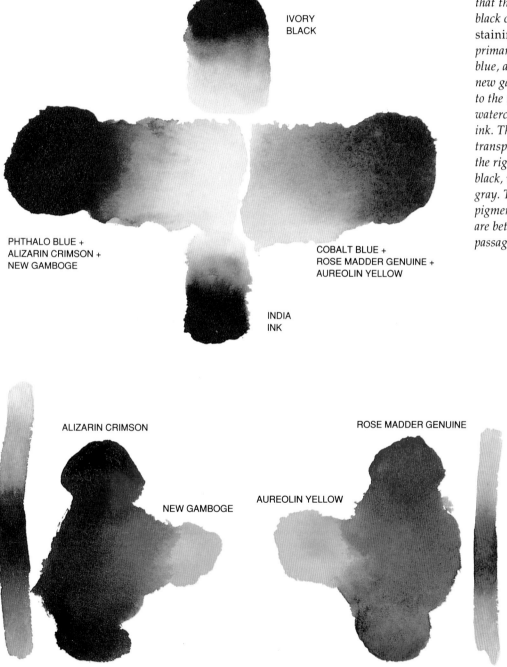

IVORY
BLACK

PHTHALO BLUE +
ALIZARIN CRIMSON +
NEW GAMBOGE

COBALT BLUE +
ROSE MADDER GENUINE +
AUREOLIN YELLOW

INDIA
INK

To me this photo illustrates that the most profound black can be mixed from the staining transparent primaries on the left: phthalo blue, alizarin crimson, and new gamboge. Compare it to the ivory black, a tube watercolor, and to the india ink. The nonstaining transparent primaries on the right can only approach black, with a dark purple-gray. This is because these pigments lack intensity and are better suited to delicate passages than bold ones.

ALIZARIN CRIMSON

NEW GAMBOGE

PHTHALO BLUE

ROSE MADDER GENUINE

AUREOLIN YELLOW

COBALT BLUE

Brown is just another proportion of the three primaries, and it can range from warm (burnt sienna) to cool (sepia) in tone, depending on the mix. As with black, a richer, bolder brown can be mixed from the staining transparent primaries (left) than from the nonstaining ones (right).

ACRYLIC PIGMENTS

There is much less to say about acrylics, because they lack so many of the idiosyncrasies that characterize watercolor pigments. This makes for less historical and anecdotal fascination, but certainly simplifies painting! Many of the characteristics discussed above regarding watercolor are not relevant for acrylics. For example, it doesn't matter whether the pigments are staining or nonstaining, because acrylics just don't lift off, period. Generally, acrylics all seem to be quite transparent, and those watercolor pigments that are usually considered opaque, such as the cadmiums, seem more transparent in acrylic. Tinting strength also does not seem to vary so much in acrylic, though there is no question that phthalo blue is still the most intense pigment on my palette. Graininess in acrylic seems to be about the same as in watercolor, cobalt blue being the only grainy color I generally use in acrylic. The main remaining point for comparison between the two media is hue.

Red: In acrylic I use two reds that correspond, to my eye, to watercolor's rose madder genuine and alizarin crimson: quinacridone red and quinacridone crimson. Both these reds tend toward the blue, but are receptive to a touch of yellow to bring them closer to true red. Just as with watercolor, I keep a jar of cadmium red tightly closed (since I use it seldom) for those rare occasions when I need a truly brilliant true red.

Yellow: Hansa yellow medium is a fine golden yellow, pretty close to true, and transparent. My very favorite acrylic color is quinacridone gold, which looks like raw sienna when undiluted, but when mixed with water and applied to paper takes on the loveliest clear golden hue. It mixes well with all the other pigments on my palette, and I use it more than any other.

Blue: Acrylic offers the same hues as my preferred watercolor pigments: cobalt and phthalo.

Green: What I said above about mixing green in watercolor applies also to acrylic. I might add that my most frequent green mix is cobalt blue and quinacridone gold, which results in a soft gray-green that I find quite appealing and broadly useful.

Orange: For bright orange, I use hansa yellow and quinacridone red; for burnt orange, I use quinacridone gold and crimson. For in-between oranges, switch the combinations around: yellow and crimson, gold and red.

Purple: For brighter, high-key purples, I mix quinacridone red and cobalt blue or phthalo blue.

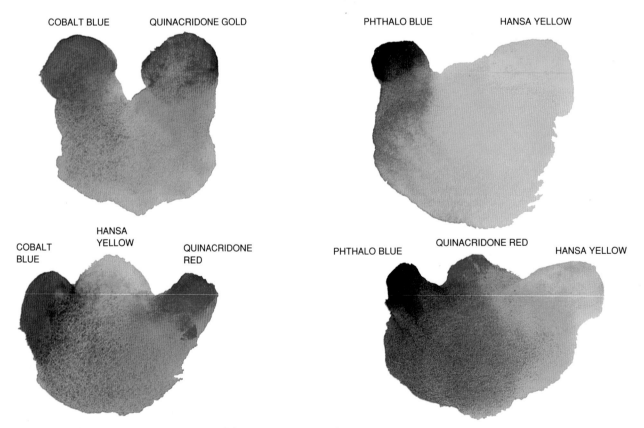

Greens mixed from various combinations of the primaries in acrylic pigments.

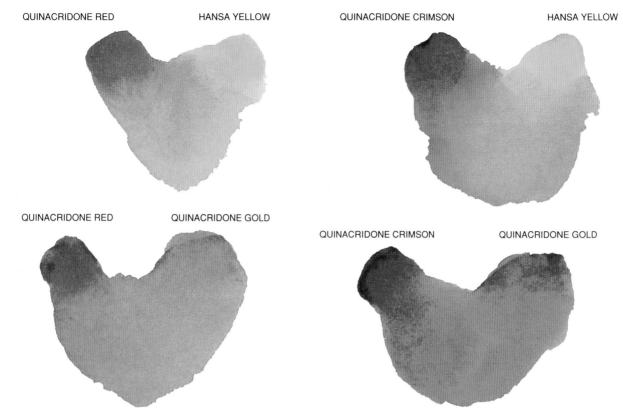

QUINACRIDONE RED HANSA YELLOW

QUINACRIDONE CRIMSON HANSA YELLOW

QUINACRIDONE RED QUINACRIDONE GOLD

QUINACRIDONE CRIMSON QUINACRIDONE GOLD

Oranges mixed from various combinations of the acrylic reds and yellows.

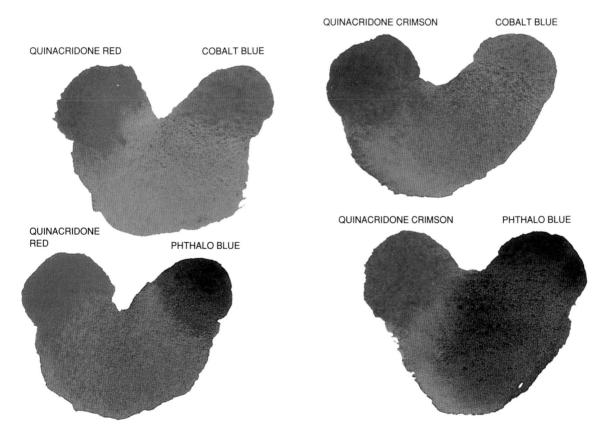

QUINACRIDONE RED COBALT BLUE

QUINACRIDONE CRIMSON COBALT BLUE

QUINACRIDONE RED PHTHALO BLUE

QUINACRIDONE CRIMSON PHTHALO BLUE

Purples ranging from bright to dark, mixed from acrylic reds and blues.

The same variety of grays is accessible in acrylic as in watercolor.

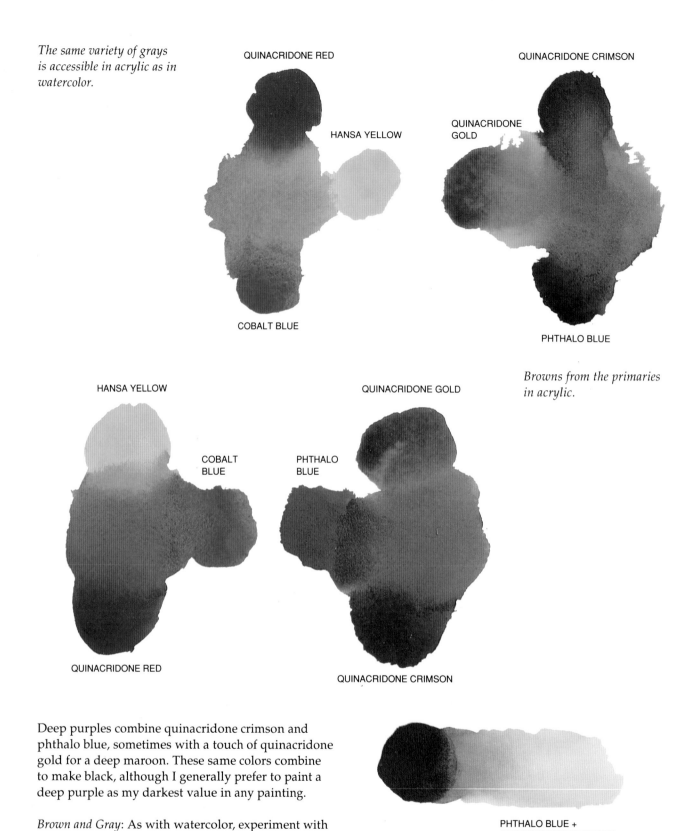

QUINACRIDONE RED

HANSA YELLOW

COBALT BLUE

QUINACRIDONE CRIMSON

QUINACRIDONE GOLD

PHTHALO BLUE

Browns from the primaries in acrylic.

HANSA YELLOW

COBALT BLUE

QUINACRIDONE RED

QUINACRIDONE GOLD

PHTHALO BLUE

QUINACRIDONE CRIMSON

Deep purples combine quinacridone crimson and phthalo blue, sometimes with a touch of quinacridone gold for a deep maroon. These same colors combine to make black, although I generally prefer to paint a deep purple as my darkest value in any painting.

Brown and Gray: As with watercolor, experiment with mixing red and green in varying proportions to create browns, and the three primary colors to create lively grays. However, since acrylic paints set up much faster than watercolor, it is riskier to combine colors directly on the paper or on your brush.

PHTHALO BLUE +
QUINACRIDONE CRIMSON +
QUINACRIDONE GOLD

Black from the dark primaries in acrylic is similar to the black achieved with their equivalent pigments in watercolor.

GLAZING

By glazing you can theoretically layer several transparent washes to produce the same color as if you had mixed all the pigments together on your palette. In practice the results are not the same, but have equal validity depending on the effect desired. To demonstrate the concept of glazing, I've photographed an arrangement of three commercially produced sheets of transparent plastic called the Tri-hue color keys, which have been tinted with gradations of the primary colors. With this technique all the hues discussed above can be approached by combining the three primaries. The fly in the ointment is that paints applied to paper do not always behave as neatly as sheets of overlapping tinted plastic. However (perhaps because they are akin to plastic), acrylics come closer to this effect than watercolor.

GLAZING IN WATERCOLOR

In watercolor it is even more important than in acrylic to allow both paper and paint to dry thoroughly between glazes. Furthermore, glazing is practical only with transparent *staining* pigments, such as phthalo blue, alizarin crimson, and new gamboge, as the initial washes. The reason, of course, for using staining pigments is to reduce the loosening and lifting of the underlying wash(es) while glazing on a new wash. However, by the same token, the final glaze could be in transparent, *nonstaining* pigments, in the expectation that there would be no further passages of a wet brush over that glaze to lift and blur the pigment.

Remember that dried washes of nonstaining watercolor pigments will be loosened by a wet brushstroke over them. It is the *second* brushstroke over the same area that either lifts off pigment from the previous wash or mixes that loosened pigment with the paint on the brush, creating mud in many cases.

It is *theoretically* possible to glaze all layers with nonstaining pigments, providing that the brush *never* makes more than one passage over the previously washed-and-dried area for each layer of color. This would, however, require an enormous vigilance.

Now it may seem that the above paragraphs contain contradictory advice. You can/can't glaze in watercolor; you can/can't glaze in nonstaining watercolor pigments. To restate the premise: Of course you can glaze in watercolor, even with nonstaining pigments, but it is very difficult to do so and arrive at fresh, glowing results. If you care to try it, the one-stroke glazing rule outlined above will work. If you want to get fresh, glowing results the easy way, glaze with acrylic.

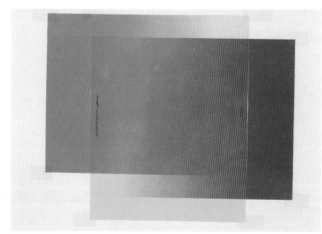

These Tri-hue color keys are three sheets of transparent plastic tinted in gradated primary colors. By moving them around in overlapping patterns, you can approximate just about any color there is. This is a useful exercise for understanding the possibilities inherent in glazing.

To illustrate how glazing can approximate overlapping layers of tinted plastic, I've painted a rendition of the Tri-hue color keys arranged as just shown, using acrylic paints.

GLAZING WITH ACRYLIC

The luminous effect of overlapping sheets of tinted plastic can be closely re-created in acrylic *only* if successive paint layers are laid down on a completely dry base. This means the paper must also be completely dry, which takes longer than the drying of the paint. For a while I was mystified that my paintings on 300 lb. paper seemed less luminous than those on 140 lb. paper. Then I realized that, because the 300 lb. paper was capable of absorbing more water from a large wash, it was taking longer to dry. If I proceeded with my next wash when the paint was dry but the paper was not, something seemed to happen to the glaze to dull it. Therefore, when glazing, it is advisable to find something else to do while waiting for underlying washes to dry. When planning my day, if I am about to begin a new painting, I save my errands and chores to do after the initial washes, since the biggest washes always seem to come at the beginning of a painting. When I come back to the studio, the piece is ready for the next glaze.

It is theoretically possible, and might be an interesting tour de force, to make a painting entirely by successively glazing only the primary colors. However, because the paper would have to dry after each glaze,

this would be an exceedingly tedious and reasoned process, inconsistent with spontaneity. Though I would not be inclined to use this approach, for the sake of completeness I've done an abbreviated demonstration of how it would work in acrylic.

When I use glazing in my acrylic paintings, it is generally to alter the hue or value (lightness/darkness) of a previous wash, or to smooth it out. The latter attribute of an acrylic glaze is helpful when vagrant brushstrokes or unintended water effects (such as blooms) mar a wash you would prefer to be smooth, such as a clear blue sky. Often a glaze will magically equalize such bloopers.

Another very useful approach is to glaze with a dull or dark color an area that needs to be suppressed in order to harmonize better with the rest of the painting. This solution is for practical purposes unavailable in watercolor, because such a glaze would generally be wanted toward the end of the painting process, when glazing would blur the edges of watercolor passages and dull the paint quality. (There is a solution in watercolor—using an airbrush—but there are so few occasions for its implementation that artists who don't own an airbrush would hardly be advised to acquire one for this use alone.)

The drawing for a three-color acrylic glazing demonstration.

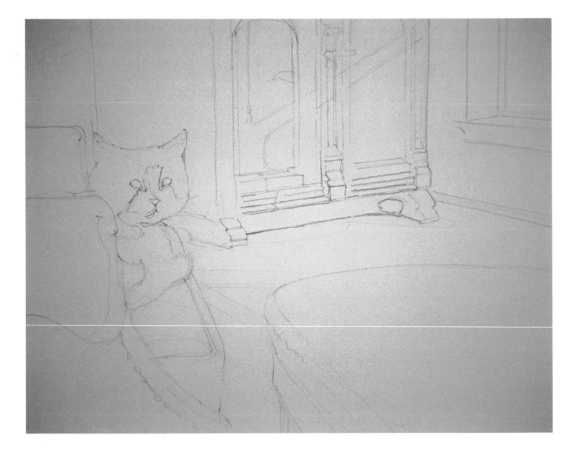

The first layer is yellow because it works better to glaze red and blue over yellow than vice versa. I've used quinacridone gold for the dark yellow areas and hansa yellow for the lighter areas.

Next I add the red tones, using quinacridone red and crimson.

Finally I add the blue, using phthalo blue for dark areas. Notice that a convincing black does emerge from a layering of the three dark primaries. In other respects, the painting lacks subtlety, but it does show that, in principle, a multicolor painting can be achieved by glazing with the primaries in three steps. Actually, this is the basic process used in printing color reproductions (as in this book), except that black ink is added to the primary colors of blue (cyan), yellow, and red (magenta).

RESERVING WHITES

Since transparent painting by definition precludes the use of white pigment and relies on the white of the paper, it is necessary to plan ahead to reserve the areas meant to be white. This is true of both of the media we are covering here, but even truer of acrylic, in which few compensations are available for a failure to reserve.

It is, of course, quite easy to reserve large white areas by painting around them. It is the small white areas that pose a problem, especially when you want a smooth wash surrounding those spots. For example, pale tree branches highlighted against a forbidding sky can be a real challenge for the transparent painter; painting *around* all those branches would inevitably result in a choppy-looking background. The simplest solution is to use masking fluid to prepaint the white area to be saved before painting in the surrounding wash.

MASKING FLUID

Masking fluid is a liquid latex, ideally about the same consistency as the paint you are using, which can be brushed onto paper. When the fluid dries, it forms an impermeable mask over the paper it covers, thus preventing paint from reaching the paper in those areas. You should leave the mask in place until all intended surrounding washes have been completed, and then remove it. I used to wear holes in the skin of my thumb rubbing off masking fluid until I discovered the inexpensive gum-rubber pickups available in art supply stores.

After trying most of the available brands of masking fluid, I settled on Winsor & Newton's white fluid. This brand and some others come in tinted versions to make it easier to see where the fluid has been painted. This advantage must be traded off against the disadvantage that in the course of painting, the area that is intended to be white at the end is in the meantime some other hue that can be confusing in judging the color balance of the work in progress.

It is possible to check the areas painted with masking fluid by using the same approach as for checking wetness: Place the eye at an angle to the light and paper so that the gloss of the fluid (either wet or dry) can be seen.

Masking fluid can be very hazardous to brushes, and many teachers advise against using good brushes to apply it. The danger is very similar to that found with acrylics: The substance may solidify in the hairs near the ferrule and permanently ruin the brush. I have, however, the same objection to the use of inferior

brushes with masking fluid as with acrylic. The character of passages that have been painted with masking fluid should be in keeping with that of the rest of the piece, so use of inferior brushes for those passages may make them stand out as less beautifully painted.

To protect brushes from destruction by masking fluid, first wet the brush, then work soap into the hairs, especially near the ferrule. Then dip the brush into the masking fluid, and paint with it. If the passages being masked are extensive enough to take more than a few minutes, wash the brush and repeat the soaping step from time to time. When masking is completed, again wash the brush carefully.

Remember that the stroke you make with a brushload of masking fluid will not disappear as the painting progresses. Masking fluid gives a very sharp edge to a stroke and, especially in a painting with many soft or blurred edges, the sharp outline of an area that has been masked may look out of place.

Masking fluid becomes more difficult to remove from paper if the areas it covers are dried with a hair dryer. I have also found that soft watercolor papers (such as Whatman) sometimes tear when I attempt to remove dried masking fluid. It is therefore best to use tougher papers (such as d'Arches) when anticipating the use of masking fluid in a piece.

In general, the effect of masking fluid is the same whether you are painting with watercolor or acrylic, but it seems to remove more easily and cleanly from an acrylic painting.

Because masking fluid is a kind of rubber, it acts as an eraser for any underlying pencil marks, which is important to keep in mind when painting the fluid over a carefully drawn area that you intend to paint into afterward.

One final note on masking fluid: You may apply it over an area that has already been painted, to preserve an area not white, but paler than the surrounding washes. This is more effective than painting a preserved white area after the masking fluid has been removed, because (in watercolor) the dark edges of the surrounding wash may be blurred in so doing. This approach also makes it easier to see where you are painting the masking fluid. When the fluid is removed, if the underlying wash is in watercolor, it may become somewhat paler than it was painted originally (the erasing action at work). With watercolor it is a good idea to compensate by intensifying the underlying color. If the underlying wash is in acrylic, masking fluid does not seem to affect it at all.

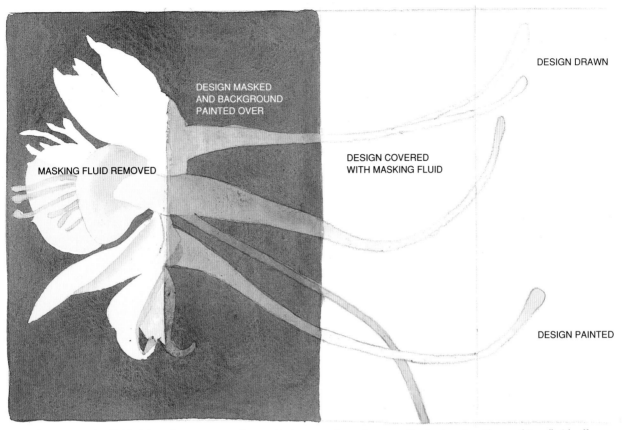

MASKING FLUID REMOVED

DESIGN MASKED
AND BACKGROUND
PAINTED OVER

DESIGN DRAWN

DESIGN COVERED
WITH MASKING FLUID

DESIGN PAINTED

This illustration is divided into four parts to demonstrate the stages of using masking fluid to reserve whites. At the far right, the ends of the "tails" of the columbine blossom are shown, drawn and painted. The artist has the option of applying masking fluid over a painted area that is to be lighter than the background, or over unpainted paper.

Second from right: The "tails" have been coated with masking fluid. Third from right: The masked area and background have been painted over with the background color. The masking fluid must be completely dry before you paint over it, and it is unwise to hurry the drying with a hair

dryer because the heat makes the masking fluid adhere more strongly to the paper. This is especially true with watercolor.

Far left: When the background color has completely dried, the mask may be removed with a rubber pickup. Where the underlying design has been painted in, the color is undisturbed when the mask is removed, if the painting is in acrylic. If it is in watercolor, the color may be somewhat faded by removal of the mask. If masking fluid is painted over a pencil drawing, the drawing may totally disappear when the mask is removed, so you may want to delay drawing interior details until after the background is established.

Another way of masking paper from pigment is to apply a resist—some substance that repels water—prior to applying paint. For example, a white crayon or candle rubbed on watercolor paper would resist the penetration of paint to the paper, preserving the white marks made in wax. Unfortunately, the mark of a crayon on watercolor paper is often inconsistent with the type of mark made by a watercolor brush, which could create a disjointed appearance in the final work. Once applied, the effects of the wax cannot be removed or overpainted. It is, however, possible to remove the *appearance* of wax residue by covering the affected area with paper toweling and pressing with a hot iron.

This melts the wax and causes much of it to be absorbed into the toweling. There nevertheless remains behind enough wax to continue to resist any further application of paint.

DRAFTING TAPE

Sometimes it is helpful to have a removable mask that forms a straight edge. In such cases, drafting tape or removable transparent tape can be placed along the line in question. Drafting tape looks a lot like masking tape but is less sticky; like a Post-it note, it can be removed without damaging the underlying paper. Both kinds of tape are available at art supply stores. When

Using a wax resist. Since the crayon stroke covers only the top ridges on the textured watercolor paper, paint penetrates to the "valleys" in the paper's surface, creating a textured negative image. The trick with a wax resist is integrating this textured effect into the overall painting, which can be difficult unless the painting has several applications of this technique scattered throughout the composition.

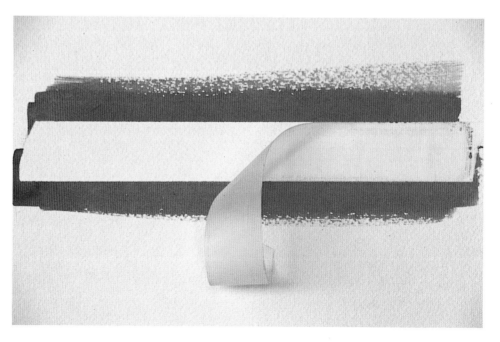

Using removable transparent tape as a mask. Notice that paint doesn't stick to the tape at all.

using a tape mask, allow the paint to dry completely before removing it.

FRISKET

Finally, white areas can be protected with frisket. Frisket is a clear plastic film with low-tack adhesive on the back (rather like drafting tape) that can be cut into a shape conforming to the area you want to protect. You can use a scissors and then remove the backing and apply the frisket, or you can apply an oversize piece of frisket to the work in progress and cut the outline with the very delicate touch of an X-Acto knife (taking care not to score the underlying watercolor paper). The problem with frisket is that *wet* washes will seep under the edge of the frisket and create a mess. A thick application of paint, brushed *away* from the edge of the frisket, will work pretty well. Or you may use frisket with an airbrush, which is its primary intended use.

Frisket may be most useful in protecting an area where any accidental deposit of paint would spell disaster. Say, for example, in a landscape with a clear blue sky (which traditionally would be painted first) you have in mind to paint the foreground vegetation with strong gestures. If flying paint were to land on the sky, the painting would be a loss. A piece of frisket over the sky area would protect it while keeping it visible, allowing you to maintain balance in the composition.

My attempt to mask the columbine blossom with frisket was less successful than when I used masking fluid. The complicated edges of the design taxed the ability of the frisket to keep paint from creeping under it, even though I stroked the thick paint only outward from the frisket edges.

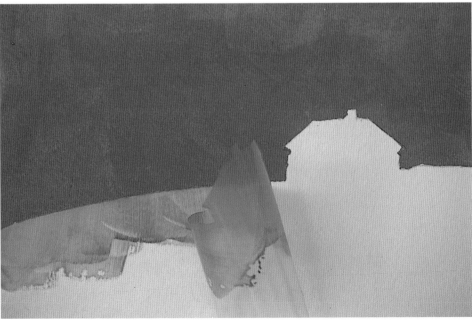

This simple design is better suited to a frisket mask, although the results are still not perfect.

RECOVERING WHITES

By recovering whites, we mean removing pigment to reexpose the white of the paper. The usual methods are washing, scraping, and erasing.

WASHING

Acrylic, of course, cannot be washed off when dry, but limited success can be had in washing off acrylic when wet. Once again, remember that acrylic tends to set up very quickly once it touches the paper, so quick action is necessary. Say a drop of acrylic paint falls off the brush into a place where it does not belong. If the underlying paint is dry, or the paper is unpainted there, a fast swipe with a clean, damp, natural sponge may remove the vagrant spot. Chances for removal are better if the underlying paper *has* been painted, because the layer of dried acrylic will slow the absorption of the spot into the paper. If there is too much paint in an area—for example, if it is puddling and in danger of forming a bloom, or if the density of the color seems too intense for your purposes—controlled removal of some of the paint is best achieved with a clean thirsty brush.

Washing has much more breadth of application in watercolor. The methods of washing wet watercolor are the same as for acrylic. With reference to dried paint, you may actually *plan* to lift off some watercolor pigment to create particular effects. Lifting off is most effective with the nonstaining pigments (especially manganese blue, rose madder genuine, cobalt blue, aureolin, and the earth colors), and the paint *must* be dry before lifting off is attempted. If the surrounding area is unpainted, the handiest way to lift off is with a clean, damp, natural sponge. Remember that wet paper is more tender than dry paper, and gentle rubbing is called for to avoid abrading it. Abraded paper is more absorbent than unabraded, which will cause future applications of paint there to appear darker than the surrounding areas. If the area to be washed is large, and there are no areas of the piece you want to preserve, you can even soak the paper in a tub and wash it with a sponge, or run it under the shower. Generally, even with nonstaining pigments, there will be a faint residue of color, but a fresh start is often possible nevertheless.

To wash small areas with control, there are two methods. You can pass a clean, wet, but not dripping brush over the area to be washed, and then blot the area with tissue or paper toweling. If the pigment is stubborn, a bristle brush may do a better job of scrubbing, but again, be careful not to abrade the paper, unless the washed area is not to be repainted.

The second method involves masking neighboring areas with drafting tape, frisket, or even stiff paper, and then wiping the area to be washed with a clean, damp sponge. Always wipe *away* from the protective mask, to avoid water seeping under it to create a messy edge.

SCRAPING

With either watercolor or acrylic, if the paint is wet and fairly thick, a pale mark may be scraped into the pigment. This method of retrieving white (or near-white) is a little tricky, requiring a judgment of the thickness and wetness of the pigment, and should be practiced before you attempt it on an actual painting. Essentially, scraping pushes damp paint aside to reveal

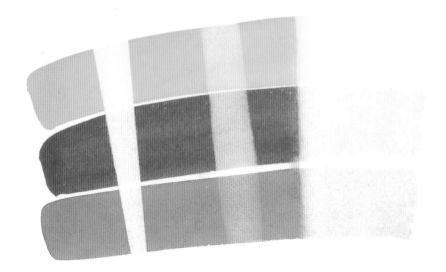

This illustration demonstrates three ways of lifting off transparent nonstaining watercolor pigments (primaries aureolin yellow, rose madder genuine, and cobalt blue). At the far left, the cleanest lift-off is achieved using a drafting-tape mask on both sides and wiping the wedge-shaped area with a clean, damp sponge. I emphasize damp, *because if the sponge is too wet, water will seep under the edges of the tape and ruin the clean lines. The center lift-off was made with a single swipe of a clean, wet brush, and the wet mark was then blotted with a paper towel. The area to the right was wiped with a damp sponge. This approach works best for large areas.*

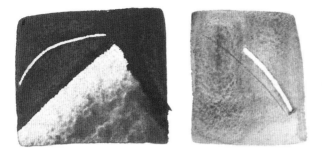

Left: Scraping a mark into wet paint, using the corner and then the flat edge of a credit card. On the right, the fine dark line is made by scraping into thin wet pigment with a sharp point. When the pigment is a little drier, a light line can be made with a broader point. A sharp point will always scratch the paper, leaving a dark line in wet or damp pigment.

Here are several methods of scraping into dried paint. The rough scrape and area scrape were made with the flat edge of an X-Acto blade.

the paper beneath. The implement used determines the character of the mark made. For example, for a broad mark, the edge of a discarded credit card or a rubber kitchen scraper is useful. The harder the edge, the more cleansing (and abrading) the scrape mark. For a narrower line, the end of an aquarelle brush, a fingernail, or any tool with a fairly broad point is useful. Too sharp a point is not very effective in pushing paint aside, and it scratches the paper. This amounts to an abrasion, which will absorb pigment from the wet wash you are attempting to scrape aside, and will have the opposite of the intended effect: A dark line will appear. (This is, in fact, a technique that can be useful for creating a thin dark line. It is most effective for this purpose if the paint is not too thick and not too dark.)

Scraping is also possible with dried paint, either watercolor or acrylic. I mentioned in Part One that one of my little indispensables at the work table is an X-Acto blade. I use this to "tickle" off those tiny flecks of paint that seem to fly off the brush and land randomly on parts of the painting where they don't belong. By tickling I mean that I use a very delicate touch and try not to scrape through to the paper, but just remove the offending fleck. Be sure that the paint fleck is completely dry before trying to scrape it off, or a mess will result.

If paint has been applied to an area and is later regretted, *and* if that area is to be white when the painting is complete, the area may be "shaved" with an X-Acto blade or safety razor blade. Gently scrape the blade across the dried pigment until the white of the paper is revealed. Do not scrape any more deeply than necessary or the erasure will jump out at the viewer forevermore. If the area *must* be repainted (this works only with acrylic), cover the scraped area with a coat of

matte acrylic medium and let it dry thoroughly before repainting. The layer of medium prevents the abraded paper from absorbing pigment too readily when it is repainted; it also allows a crisp mark, as opposed to the fuzzy mark formed on uncoated, abraded paper.

An X-Acto blade, or the corner of a razor blade, can be rapidly scratched over a painted area to create a white line. If the scratch is deep, it will pull up little globs of paper along its length; depending on the effect desired, this could either be a happy or an unhappy effect.

ERASING

The three methods of recovering whites have been covered in the order of their obtrusiveness; that is, the likelihood that a viewer will notice and be disturbed by them. Thus, erasing is the most obtrusive method and a last resort.

To erase, an ink or typing eraser is needed. For a small area, the kind that looks like a pencil is most easily controlled. For a large area, an electric eraser (if available) will save time and muscle strain. The paint must be completely dry and, as with scraping, a gentle touch is best. Erase only until the white of the paper appears. The paper will, of course, be abraded, which makes any further application of paint there hazardous. The edge of the erased mark will be soft, not sharp.

In passing, I might mention that a soft pencil eraser is useful to erase pencil planning marks when the painting is complete. I have found that neither watercolor nor acrylic is disturbed by this erasure, and the removal of pencil lines often makes the painting appear cleaner and stronger.

THE ORDER OF OPERATIONS

Conventional wisdom has it that in watercolor you must begin with the palest washes and progress gradually toward the application of darks. The practical basis for this rule is that when, in watercolor, a wet wash abuts or overlaps a dried wash, the contact tends to blur the edge of the dried wash. This is much more noticeable when the blurred edge is a dark hue than if it is light. Thus, progressing from light to dark preserves the cleanness and crispness of the work.

The downside of this rule is that value contrasts, often the very life of a painting, do not become apparent until the very end. This can interfere with judging the balance of the piece until it is so far along that corrections may be very difficult.

If you are painting in watercolor, it is possible to place darks early on if you are careful to avoid placing darks in areas where you are certain later washes will abut or overlap. Also, if the dark is painted with staining pigments (such as alizarin crimson or phthalo blue), the edges will be less susceptible to blurring.

If you are painting in acrylic, the "order of battle" is irrelevant, because the edges of previously painted areas will *not* blur (if they are dry). It is possible to paint lights and darks in any order desired. What freedom!

This illustration shows why it is generally recommended to paint light values first in watercolor: When a dark value is painted over a light one, as at left, a crisp mark results, but painting light over dark causes the dark edge to soften, which doesn't look so clean.

DARK OVERLAPS LIGHT

LIGHT OVERLAPS DARK

This sequence demonstrates the recommended order of painting in watercolor. The palest washes defining the lighter areas of the cat have been placed first.

Adding details to the lightest parts at this point gives me a feeling of accomplishment, though there is no technical reason why these couldn't be added last.

I work on the dark background behind the cat next. I have covered part of the cat's (to-be-black) back with this color, which will deepen the black glaze that comes later.

Not satisfied with the evenness of the background wash, I have glazed over it, a tricky undertaking in watercolor. I avoided mud and unwanted marks in this area by working quickly and making sure I made only one passage of the brush over any given spot.

Finally I add black to the body of the cat, and to other black details. The painting is finished.

KNOWING WHEN TO SAY WHEN

My grandmother, an artist trained at the Art Institute of Chicago at the turn of the century, used to say that every artist should have another artist standing behind him to hit him over the head when the piece is finished. What she meant is that often we find it difficult to look at our own work objectively enough to realize when it's time to quit. There also seems to be a strong tendency to overwork rather than underwork a painting.

Sadly, few of us have an artist (especially one whose judgment we trust implicitly) handy to tell us when enough is enough, so we have to decide for ourselves. Here are a couple of tricks to help get the distance to make a good judgment: First, at each stopping point in a piece, when it is dry enough to stand it up without danger, place it somewhere where you can stand back from it. It is even better if the work in progress can be stood up in a place where you will notice it while going about your daily routine; where it can, as it were, take you by surprise. Then you will have a fresh eye, and problems you may not have noticed before may surface, or you may realize you like it just the way it is and call it done. Another trick is to place the painting where it will be reflected in a mirror. The mirror image often reveals imbalances that you don't notice when the painting is seen the right way around. Finally, it helps in keeping objective to be working on more than one piece at a time. You are then less absorbed in each of the works in progress and less likely to be blinded to their flaws and virtues.

Since most of the people who own art are *not* artists, it is often helpful to consult friends or neighbors on their opinions of a piece you have judged to be finished. (It is hazardous to show people work in progress, because they cannot possibly know your intentions, and may lead you astray.) Some of us paint only for our own pleasure, in which case no one else's opinion of a piece matters. Personally, if I fail to communicate to the average viewer something of interest to both of us, then I have trouble thinking of the piece as a success. On the other hand, guard against extreme susceptibility to other people's opinions, or you may end by pleasing no one, least of all yourself.

Sometimes a painting that is finished but lacks the desired impact will benefit from judicious cropping. I have in my studio mats of varying sizes that I can place over larger paintings to see if the composition and/or impact can be enhanced by eliminating the less interesting or successful parts of a piece.

This is another exercise in which someone else can be helpful by saying "warmer, colder" as the mats are moved around and exchanged. One clue that cropping might help a piece is if viewers consistently comment that they like a particular *part* of a painting. A painting that is a harmonious whole should not have parts that stand out too much. Perhaps that part should have constituted the entire piece. I have often noticed in my teaching that students paint more of a scene than really interests them. Their pleasure in painting has often been greatly increased when I encouraged them to zero in on the part that intrigued them most and forget including anything else in the composition. Backgrounds, foregrounds, and extraneous details, if they do not fascinate the artist in themselves, will be painted with boredom. Boredom shows in a painting!

Finally, there are times when a painting that is not working is best abandoned. Discouragement also shows in a painting, and overworked and tired pieces are often the result of a misplaced determination to hang in there to the bitter end. Instead, if a subject matter is very interesting but the attempt to render it has failed, a fresh start often leads to a quick and satisfying conclusion. You may well find that the work done on the failed piece is practice for the second attempt, and practice may make perfect in such a case.

If the drawing for the failed piece was carefully done and redoing that discourages a second attempt, it is worthwhile to trace the drawing and transfer it to a clean sheet of paper. To trace, you will need a sheet of translucent tracing paper at least as large as your painting. Tape the painting and the tracing paper down so that they can't shift. Then trace the drawing with some implement other than pencil, such as a bright marker pen. This allows you to keep track of what you go over, later on. Then flip the tracing paper over and go over the lines that show through with broad, heavy marks of a soft pencil or graphite stick. Densely drawn areas are most easily covered entirely with graphite. Now flip the tracing again so that the pencil-marked side is down, and tape it over a clean sheet of paper. Go over the lines firmly, with a pencil or ballpoint pen (something that contrasts with the original mark, so you can tell what you have transferred), taking care not to rest your hand heavily on the paper, which will transfer smudges to the clean sheet below. This procedure may seem tedious, but once you have the tracing paper in your collection of tools, it is really simpler than redoing a complicated drawing.

To conclude, this chapter has shared everything I know about the mechanics of transparent painting in watercolor and acrylic. The next chapter will demonstrate how I put some of these techniques into practice. You will be able to compare two sets of "twin" step-by-step demonstrations of two subjects, with each subject painted once in acrylic and once in watercolor.

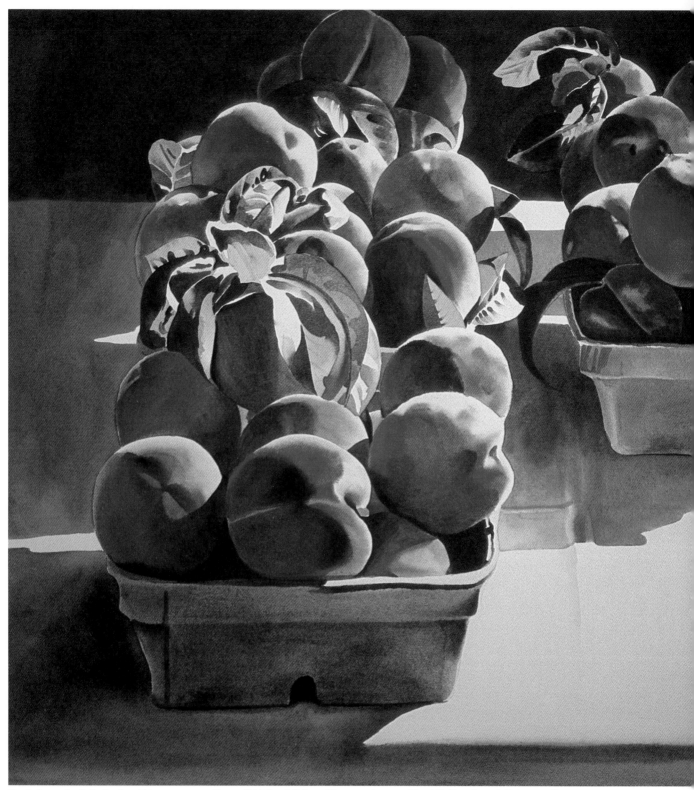

Peach Season by Julia Jordan. Transparent acrylic on d'Arches 140 lb. cold-pressed paper, 22 × 30" (56 × 76 cm). Private collection.

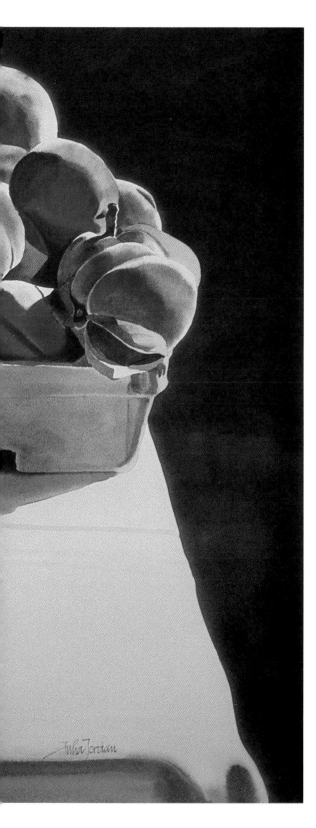

COMPARATIVE DEMONSTRATIONS: WATERCOLOR AND ACRYLIC

The following sets of demonstrations show how the same subject matter can be painted, first in acrylic, then in transparent watercolor. The object of these demonstrations is to show how similar results can be achieved with either medium, with minor differences in technique.

There are two sets of demonstrations, one of a flower subject and one of a landscape. In a larger sense, the challenges encountered in painting a close-up of a flower differ little from those found in painting a landscape. In either instance, the artist seeks to represent the essence of the subject. This requires capturing the light's interaction with the surfaces on which it falls directly and off which it is reflected; it also means expressing the character of cast shadows and the shadows on surfaces turned away from the light source. Color, large and small shapes, light and shadow, protrusions and depressions—all these occupy the painter's attention no matter what subject is being painted.

There are two additional challenges in painting landscape: simplifying the welter of *things* out there, and capturing the sense of distance and atmosphere as the landscape recedes from foreground to background. By contrast, a close-up of a single object or group of objects is already simplified by zeroing in on it, and the problems of distance have been eliminated by definition.

ACRYLIC DEMONSTRATION: FLOWERS

I love to paint flowers for the same reason I love transparent painting: Flower petals allow the light to pass through them, causing them to glow like stained-glass windows. At the same time they are substantial enough to reflect light and to cast shadows. My challenge in painting them is to represent all the manifestations of light inherent in their form and substance: translucency, reflectivity, cast shadows, and light bounce within shadows opposite to directly lighted surfaces. To focus on these wonderful qualities of light's play over the complex flower surface, I often like to zero in on the blossoms and eliminate most of the background busyness that might distract from these qualities.

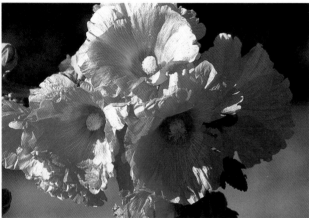

Here is the photograph on which I am basing my drawing. The particular focus of my attention with both flower demonstrations is to capture the glow at the center of the flowers, caused by the passage of light through the translucent petals.

MATERIALS

140 lb. cold-pressed d'Arches paper, 15 × 22" (38 × 56 cm) stretched with staples on a wooden board
pencil
1-inch flat brush
numbers 6, 8, and 10 round brushes
Painter's Pal palette
quinacridone red
quinacridone crimson
quinacridone gold
hansa yellow
cobalt blue
phthalo blue
matte acrylic medium
water
hair dryer
rear projection screen (optional)
slide projector (optional)

The pencil drawing with which I begin was drawn darker than usual for purposes of reproduction. Ordinarily, the pencil lines would be rather faint, to facilitate erasing them when the painting is completed. Because it is easy to get lost in the complexity of flower images, I've made the drawing fairly detailed, and for the same reason chosen to project the image rather than "eyeball" the drawing. I did take the liberty of turning a vertical hollyhock stalk on its side because I preferred the horizontal composition.

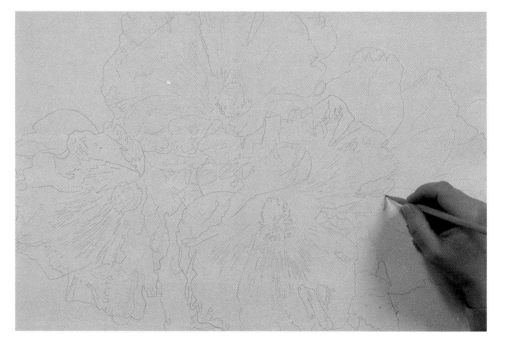

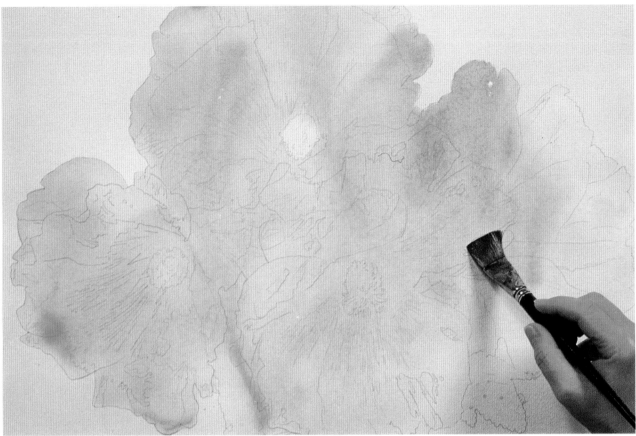

I prewet the area of the flowers with clean water, leaving the center of the upper flower dry because it is to be pale yellow. Using a 1-inch flat brush, I float in a pale pink wash of quinacridone red, adding a dab of medium to compensate for thinning the pigment with water to such an extent. The value of this wash corresponds to the lightest areas on the flowers. Areas where color appears to concentrate can be evened out with a swipe of a damp, squeezed-out brush.

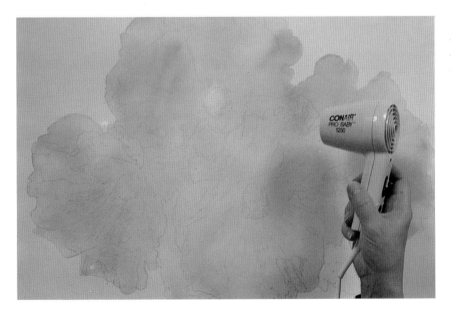

Once I am satisfied with the wash, I use a hair dryer to help it dry faster. It isn't necessary for this wash to be completely even because the texture of the flowers will be variegated.

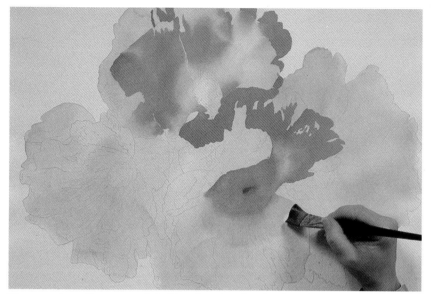

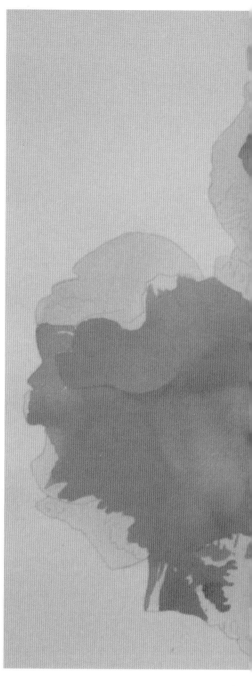

The second continuous wash is directly painted—that is, I do not prewet the areas to be painted. The shapes are so complicated, and the texture will vary enough, that it is impractical and unnecessary to prewet. I do keep a clean, wet brush in my other hand while I paint, for softening edges as I go along, as shown in the illustration. The basic color used is quinacridone red. In some areas I warmed the red with hansa yellow, and in others cooled it with cobalt blue, by dropping in the second color wet-in-wet. Here I am softening an edge of the yellow center.

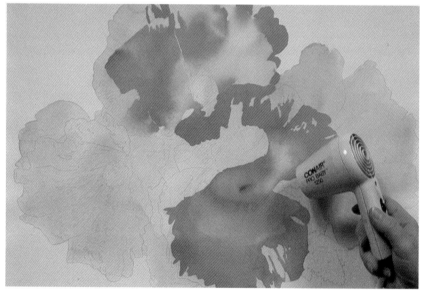

I choose a stopping place when I come to a closed edge of this fairly large wash, and use the hair dryer to prevent the development of backruns where the paint is not drying at an even rate.

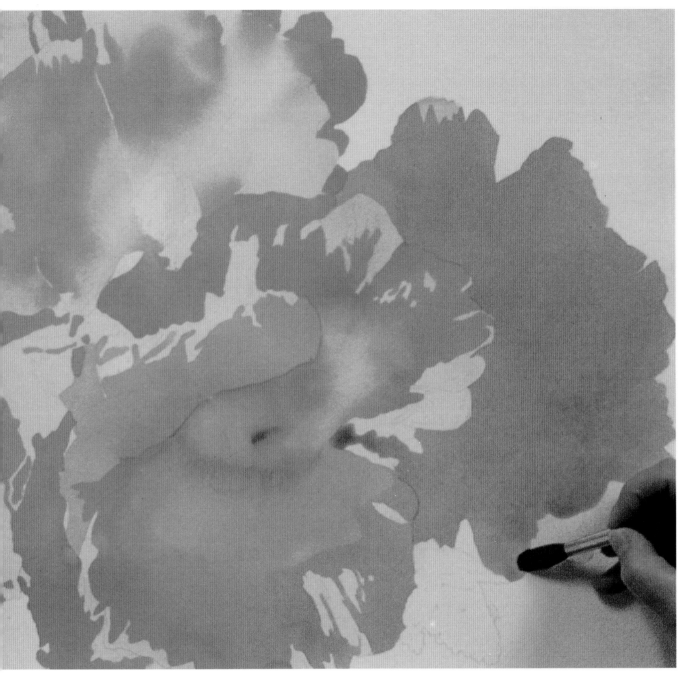

The wash of middle value is complete at this point. Most of the flower area now has two layers of paint on it, and a sense of light and shadow is emerging.

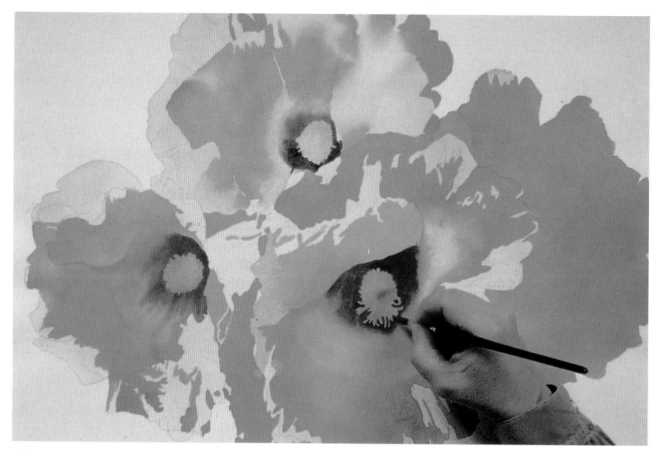

Above: I next paint the centers of the flowers, using hansa yellow with quinacridone red to warm it. On each lower flower I paint beyond the edges of the pistil with this golden hue, softening the edges as I paint, with a clean, wet brush. After this layer dries thoroughly, I switch to a smaller, round brush to paint around the pistils with a warm dark mixed with quinacridone crimson, phthalo blue, and quinacridone gold.

I consider using masking fluid to delineate the rather complicated edges of the lower center pistil, but opt finally for direct painting, as shown, frequently using a clean, wet brush to make sure the edge of the dark area away from the pistil retains its softness.

Opposite, above: It seems timely to develop some of the contrast in the painting that will make the flowers stand out from the background and establish the mood of the painting more firmly. I begin with some of the dark green leaf shapes, taking advantage of the rich yellow on my palette from painting the pistil shapes to make a dark green (by adding phthalo blue and a touch of quinacridone crimson).

Immediately I make an error, mistaking a petal shape for a bud shape and painting it green. The only option for correcting this error is not very desirable: painting it over with white acrylic paint, allowing it to dry, and glazing again with pink. The quality of bare paper can never be reestablished by covering an error with white paint, and this particular spot is too large and prominent in the painting to go unnoticed. The other option is to leave the shape green, since it looks enough like a bud to have fooled me in the first place. This I do.

Opposite, below: Next I start the background by prewetting the upper left-hand corner. I want to create a mottled effect of rich color to suggest distant vegetation, so I drop into the prewet area incompletely mixed colors that together create the effect of dark green: quinacridone gold and crimson, as well as phthalo blue. I think this wet-in-wet merging of pigments is more interesting to the eye than a flat wash.

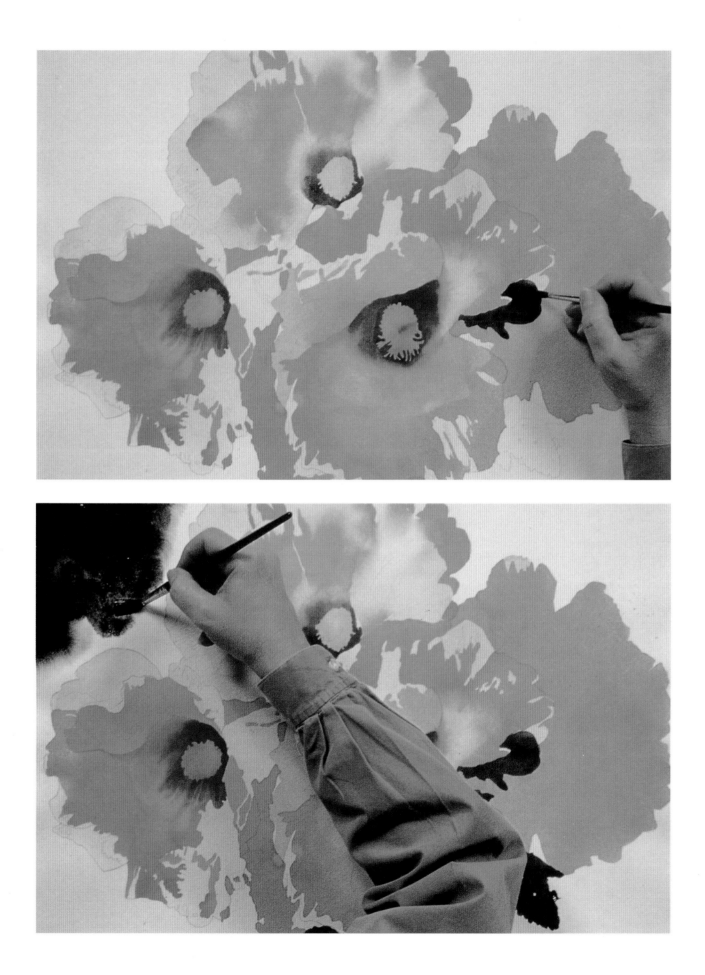

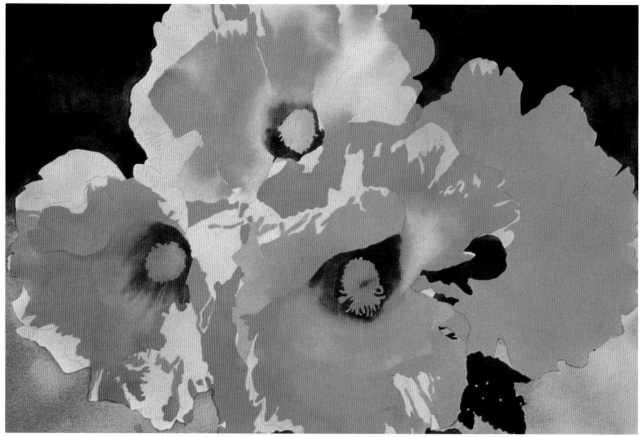

I repeat this procedure on the right side, lightening my paint puddle with water and a dab of medium to add tensile strength to the wash, and then add a bit of gold to warm it. With this mixture I continue around to the bottom foreground area. Here there is no harm in painting right over the dark leaf shapes, which will not lose the crispness of their edges in acrylic as they would in watercolor.

Because the wash is quite wet, the paper tends to form hills and valleys, despite the fact that it has been stretched. The settling of pigment in the valleys creates an effect that pleases in this case, so I do not correct it. If I chose to even out the wash while it is wet, I would pick up pigment from the valleys with a thirsty brush.

I must watch out for the small puddles that tend to form around the staples and create backruns unless the moisture is picked up with a thirsty brush.

I now enter the final stages of the painting, returning to paint the detail in the flowers. In the illustration, I am using a clean, wet brush to drag paint toward a softened edge, a technique used frequently during this phase of the work.

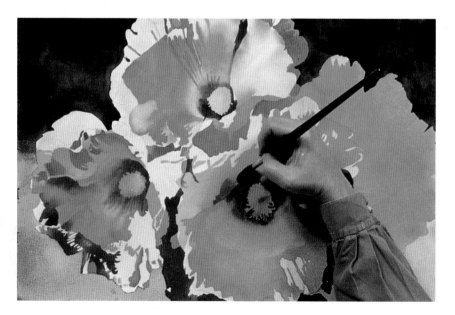

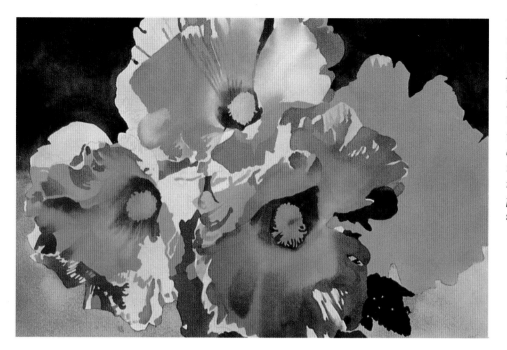

To create the soft shadows in the lower flower, I prewet the whole lower half of the flower and use a fairly dry brush to place the purplish shadows. (Remember, since it's acrylic I don't have to worry about damaging crisp edges by painting over them with water.) A dab of medium added to the diluted paint helps the soft-edged shadows hold their shape.

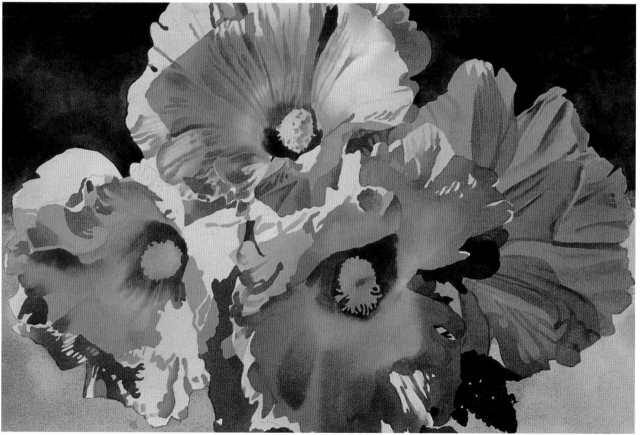

I continue adding details. Notice that some of the creases on the flowers vary in value from one end of the stroke to the other. This is done by beginning the stroke with strong pigment and continuing it with a clean, wet brush, which drags the pigment out and thins it as it goes along. I could also have chosen to prepaint the whole stroke or shape with clean water and drop strong color into one area of it. As it spreads out, the pigment will be thinned by the water already on the paper, and the stroke will have an interesting variegation.

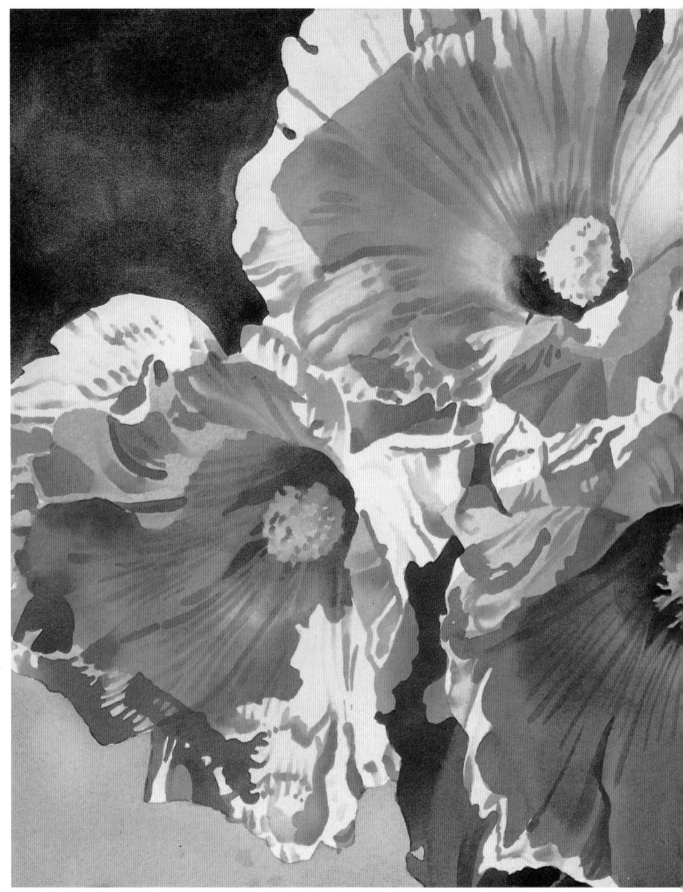

Hollyhock Quartet II by Julia Jordan. Transparent acrylic on d'Arches 140 lb. cold-pressed paper, 15 × 22" (38 × 56 cm). Collection of Joan Klein.

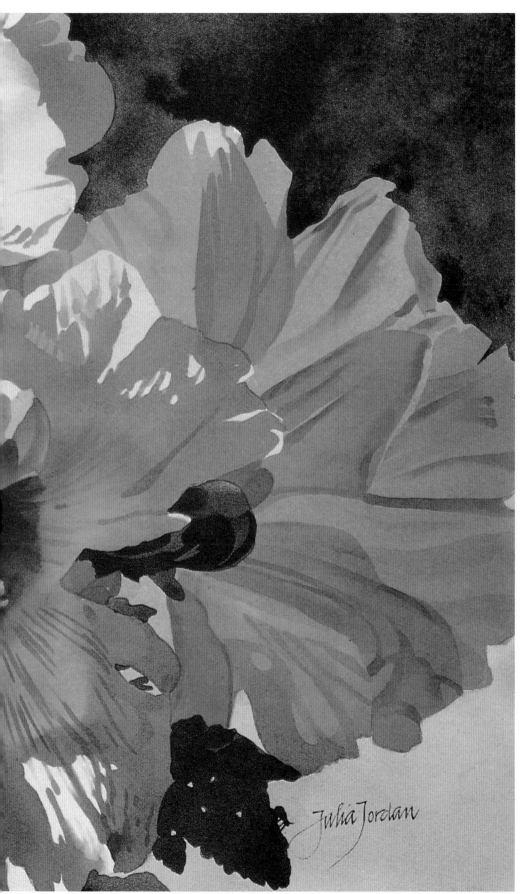

Julia Jordan

WATERCOLOR DEMONSTRATION: FLOWERS

As I painted this demonstration, the first watercolor I had done in several months, I made the discovery that flower painting in watercolor was more pleasurable than I had remembered. The runny, flowing quality of watercolor, which sometimes is a handicap, seemed in this instance to contribute to the ease and enjoyment of making the painting. This is an ineffable sense that is difficult to attribute to any concrete factor. The availability of Holbein's opera, a watercolor pigment for which I haven't found an acrylic equivalent, contributes to a flowerlike brightness in the painting

that seemed to me somewhat more pleasing than the color in the acrylic version of this subject. The only other difference in approach between these two demonstrations is the need in this one to be alert to staining versus nonstaining pigments in glazing. The first washes are all in staining pigments, and the final washes are in nonstaining pigments. This prevents inadvertent lift-off and muddiness.

MATERIALS

140 lb. cold-pressed d'Arches paper, 15 × 22"
 (38 × 56 cm), stretched with Zipp Clamps
pencil
1-inch flat brush
numbers 6, 8, and 10 round brushes
John Pike palette
opera (Holbein)
alizarin crimson
rose madder genuine
phthalo blue
cobalt blue
new gamboge
aureolin yellow
water
tissues
hair dryer
rear projection screen (optional)
slide projector (optional)

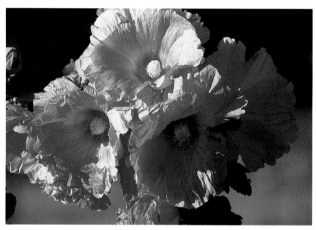

For this demonstration, I began with exactly the same photograph used for the preceding one but chose to create a slightly different composition.

The drawing is similar to that used for the acrylic demonstration, but I have included a blossom shape to the left, and invented a stem at the lower center to foster the illusion that this hollyhock is turned right-side-up rather than sideways, as it actually is. This time I have stretched the paper with Zipp Clamps rather than staples, but either stretching method works for both media. However, when using Zipp Clamps with watercolor, be sure to wipe off the clamps before each use. Otherwise the dried watercolor will dissolve when it comes into contact with the wet paper as you stretch it, and it will mess up the paper.

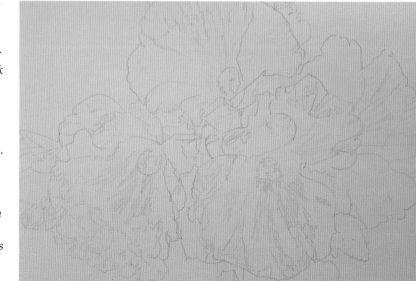

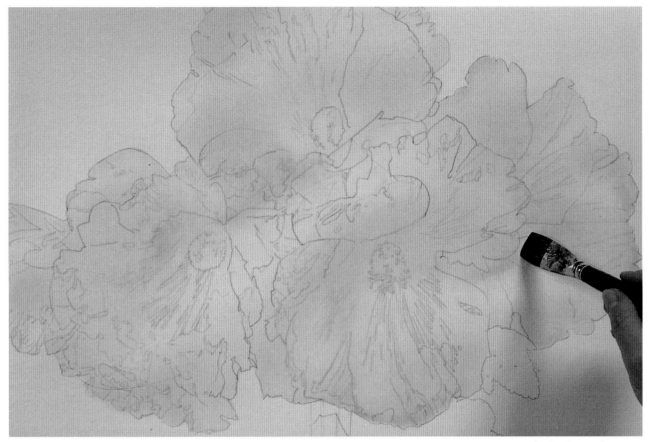

The first wash is very similar to the one for the acrylic version: I prewet the whole flower area and paint in a pale pink throughout. (This time I have failed to leave the upper pistil dry, so I need to compensate by going over that area with a clean, thirsty brush to remove as much pigment there as possible.) Since the pistils in the other flowers will be much darker, and their surrounding petals also darker, it is easiest (and leaves my options open) to paint over those pistils in the initial wash. The paint I use here is Holbein's opera, an intense fuchsia color that is wonderful for certain flowers and suitable for depicting very little else in the natural world. Opera is a staining color, making it suitable as the initial wash, since I will need to rewet and paint over it in places.

Since watercolor is even more prone to backruns than acrylic, I must be alert to their potential in this large, wet wash, which causes even stretched paper to form hills and valleys. Using a thirsty brush, I sop up some of the moisture collecting in the valleys and then thoroughly dry the wash with the hair dryer.

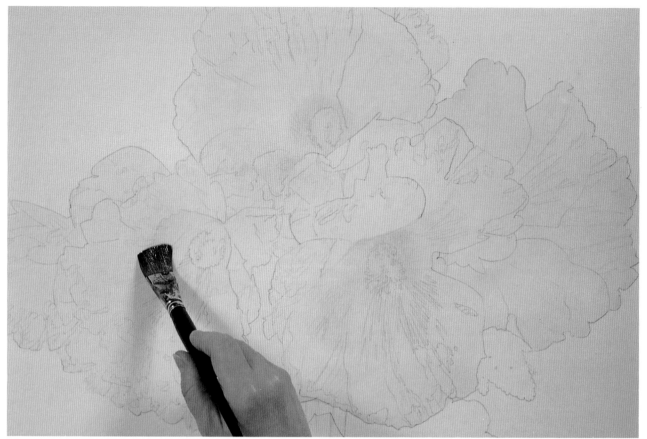

When the first wash is thoroughly dry, I prewet the center of each flower, brushing around the edges of overlapping flowers, and elsewhere painting the clean water out beyond where I want the color. This will allow the color to spread to a soft edge without ever reaching the edge of the water. Then

I drop in a fairly intense, dry brushful of new gamboge in each center, and monitor the spread of the pigment to make sure the edges remain soft (except for where overlapping petals require a sharp edge). I control the spread of pigment with my thirsty brush.

I prewet the leftmost flower shape and drop in a fairly intense brushload of opera at the top of the shape; then I blend in some alizarin crimson toward the bottom, where I want the color to warm up a little. While the paint is still quite wet, I use a thirsty brush to lift color out of areas that are to remain paler than their surroundings, thus retaining the soft edges throughout the shape. In the illustration, I am running a thirsty brush along the crack at the edge of the Zipp Clamp to prevent water collected there from creating a backrun.

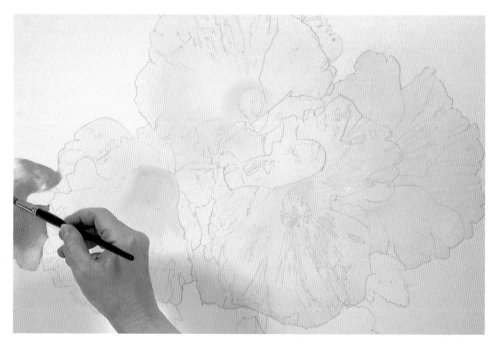

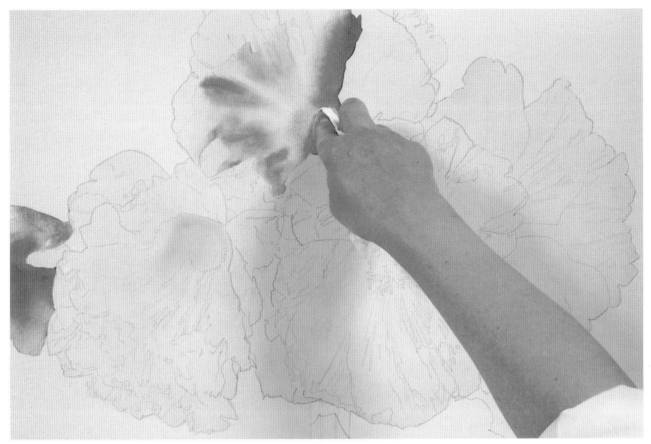

I prewet the left half of the top flower, including the center that has already been painted yellow, and carefully preserve the crisp edge at the right where the shadow area ends. While the area is still wet, I drop in a bright purple made with opera and a touch of phthalo blue, and regulate the flow of the paint around the wet area using a thirsty brush as a tool. Nevertheless, more pigment than I desire flows into the yellow area, which I blot with a tissue and quickly blow with the hair dryer to prevent further invasion of purple into this area that is to remain pale yellow. I probably would have been wiser to prewet around the shape of the pistil, but this works too.

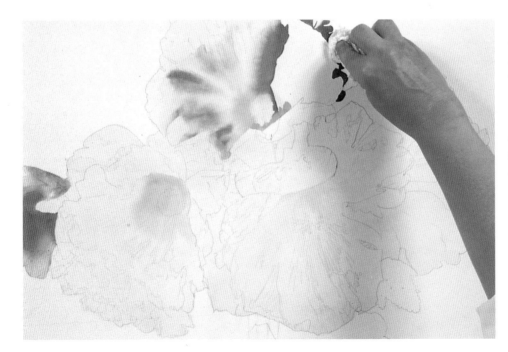

Since I have this rich purple on my palette, I am moved to paint in some of the smaller shapes at the right edge of the upper flower, but find that the color is more intense than I desire. To lighten the effect and at the same time add some petal-like texture, I press a crumpled tissue into the paint.

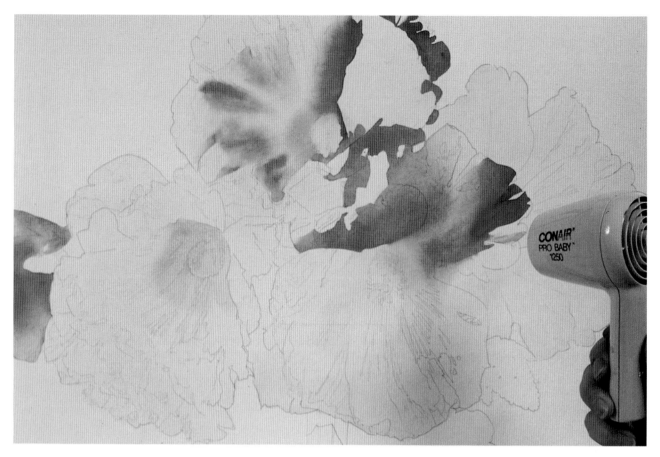

Above: This stage is similar to the corresponding one in the acrylic demonstration. I paint the midvalue wash on the center flower directly (without prewetting) and vary the color as I go along by using clear water or different pigments. The illustration shows a place where I fear I may lose control of the wetness, so after softening the lower edge of the painted area with a clean, wet brush, I quickly dry it to stop all interaction between wet areas and those that are drying faster.

At this stage, I am still using staining pigments because I know I will have to paint over these areas again later with more detail. The staining pigments will not lift off more than a tiny amount when I glaze over them, ensuring that the color will remain clean and brilliant.

Opposite, above: I decide to try direct painting on the rightmost flower, starting at the top and varying the color as I paint along. I work as quickly as possible to keep the wash even, and I find it unnecessary to use the hair dryer to prevent backruns caused by differential drying within the area. As I go, I realize that I would have given myself more leisure to complete the area, and more control over wetness, had I prewet the flower before painting.

Opposite, below: I move around the painting, adding color areas and detail, and ensuring that I give each area ample time to dry completely before going back over it. This prevents muddiness. I complete more details on the flowers before creating the contrasting leaves and background than I did in the acrylic version. This is because I want to make sure the edges of the flowers are complete before I paint in the green background. Remember, crisp edges in watercolor tend to blur if painted over, and this is especially conspicuous if you paint a lighter area abutting a neighboring dark area. It is better to paint the dark last.

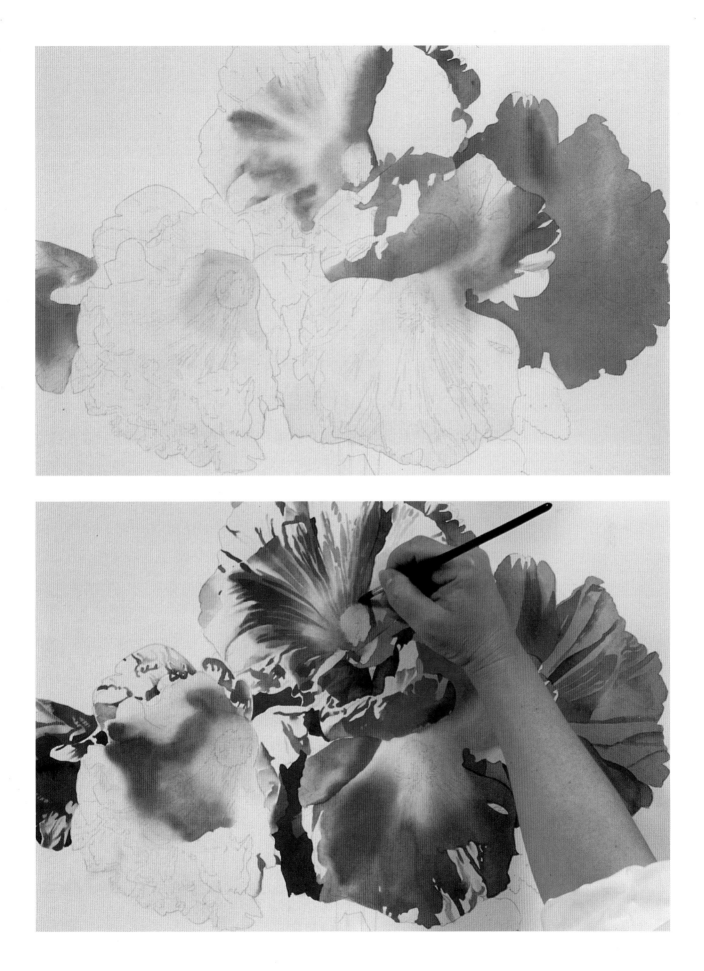

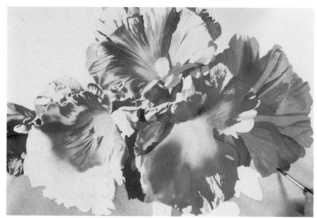

By now I've added more detail to the flowers and started the background at the bottom, even though the flowers are not entirely complete. Again, as in the acrylic version, in creating the creases in the hollyhock petals I have used the technique of beginning a line with intense color and dragging it out with a clean, wet brush to vary the value of the color in the mark.

At this stage of the painting, I have switched primarily to nonstaining transparent colors: rose madder genuine, cobalt blue, and aureolin yellow. I start the background with the paler part at the bottom so that when I fill the palette with darks for the upper background I can at the same time paint in the dark leaves at the bottom.

In watercolor, dark shapes should be painted after the surrounding light areas are completely dry; in acrylic, it doesn't matter.

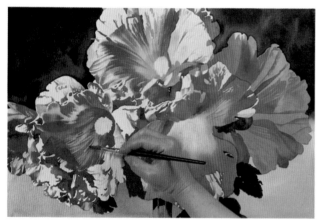

As in the acrylic version, I prewet the upper left and right background areas and drop in colors to approximate green, letting them mix on the paper to form a varied texture suggesting vegetation. I even find that backruns contribute to the interest in these areas, so I make no effort to prevent them. Continuing the detail on the flowers, I paint in the details that are darker than the lower background.

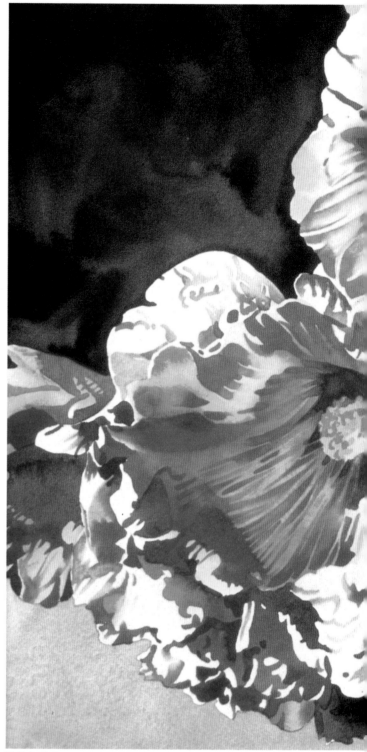

Hollyhock Quartet III by Julia Jordan. Transparent watercolor on d'Arches 140 lb. cold-pressed paper, 15 × 22" (38 × 56 cm). Courtesy of MacLaren/Markowitz Gallery, Boulder, Colorado.

The finished painting.

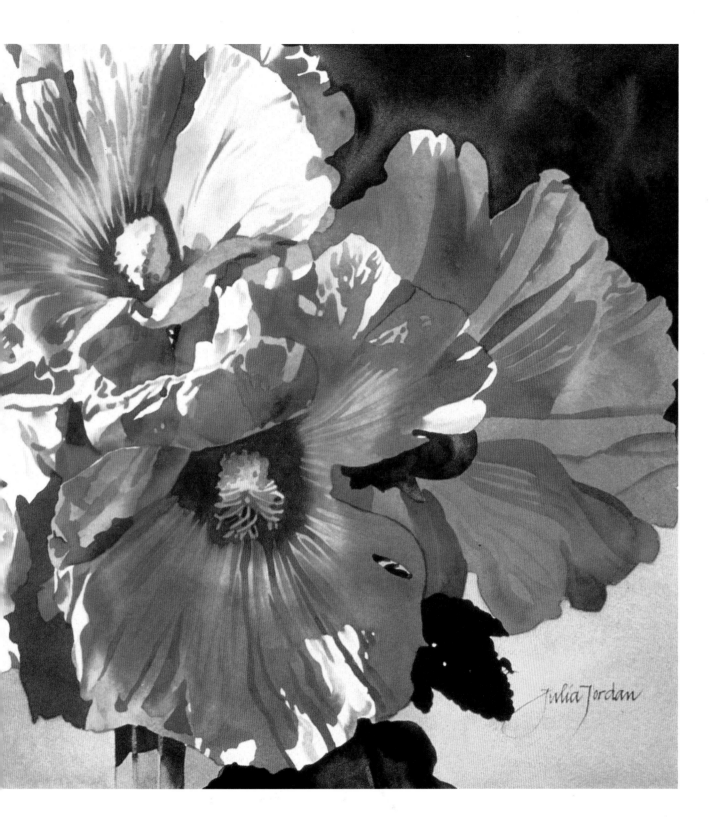

ACRYLIC DEMONSTRATION: LANDSCAPE

Most of my landscape photographs of New Mexico are taken with a telephoto lens, to zero in on the features that interest me and minimize some of the confusion of the overwhelming visual experience that New Mexican landscapes so often present. However, the telephoto lens introduces an element of unrealism that can adversely affect the "atmosphere" of a painting based on a photograph made using such a lens: The lens compresses space, causing distant objects to appear nearer than they appear to the naked eye.

It is difficult to adjust for distortions in size relationships introduced by the telephoto lens, but the artist *can* compensate for atmospheric distortion by painting distant objects more faintly and indistinctly than they appear in the photograph, to restore the impression of distance and atmospheric perspective. This I will attempt to do in these two demonstrations.

MATERIALS

140 lb. cold-pressed d'Arches paper, 15 × 22"
 (38 × 56 cm), stretched with Zipp Clamps
pencil
3-inch Big Daddy wash brush
numbers 8, 10, and 12 round brushes
Painter's Pal palette
quinacridone red
quinacridone crimson
quinacridone gold
phthalo blue
hansa yellow
cobalt blue
water
hair dryer
rear projection screen (optional)
slide projector (optional)

Compare this source photograph to the plan drawing in the next illustration. You'll see that the image has been cropped, and part of the background has been eliminated. This is an example of artistic license: The background rock formations and hills contribute nothing of interest to the composition, so its drama is enhanced by eliminating them. The eroded rock formation at the left stands out more dramatically as a result.

I have also eliminated certain distracting details, such as many of the bushy trees, while retaining enough of them to indicate the type of vegetation found at the site and the way these trees cluster along watercourses on such a rocky promontory.

The plan drawing has, again, been projected, more to allow continuity between demonstrations than because of the complexity of the subject. In fact, the drawing is a conscious simplification of the source photograph. If I were not preparing for a demonstration, I probably would have chosen to "eyeball" the plan drawing for this subject matter.

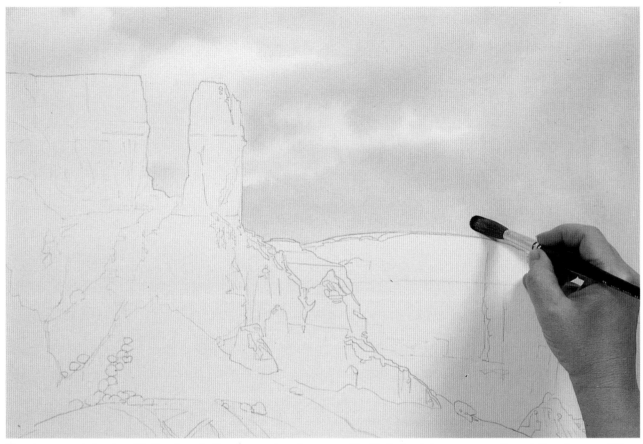

It makes sense to begin with the sky, whether in a watercolor or acrylic landscape, because it is usually one of the largest and trickiest washes, and if something goes wrong you haven't invested much work in the painting so far; you can begin over. Also, the sky is usually lighter than the rest of the painting, so other shapes are easily superimposed over it. (This is less important in acrylic than in watercolor, since with acrylic you needn't be concerned about foreground color bleeding into a sky painted at the end.) I haven't drawn in the shape of the clouds, partly because it is easy to paint amorphous cloud shapes without planning marks, and partly because the pale washes often fail to cover the pencil lines, which often remain visible even after erasure attempts.

The first step is to prepare on the palette a large puddle of diluted phthalo blue. Second, I prewet the entire sky area with clear water using the Big Daddy wash brush. If I wet the sky area of the paper first and then prepare my paint puddle, the prewetting will begin to dry and may result in unpredictable effects when I apply the paint. The effect of soft clouds is made by painting wet-in-wet around the cloud shapes with a brush that has been charged with color and then squeezed out a little. Reducing the amount of water in the brush increases the amount of control over the mark. In addition, the fact that this is acrylic, which flows around less than watercolor in a prewet wash, allows me more control during this step.

While I was concentrating on painting around cloud shapes on the left part of the sky, the right side began to dry. When I painted that part of the wash, the color was laid down less evenly because of this drier state and the tendency of acrylic strokes to set very quickly. However, acrylic carries its own unique solution possibility as well: When the sky wash has completely dried, I can rewet it and repaint portions of the sky that are not as smooth as I would like. A second glaze will smooth out the effect considerably, even though both layers of color are very thin. I use the hair dryer to dry the sky so that I can move quickly on to the foreground.

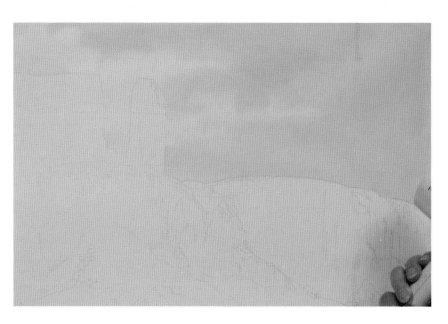

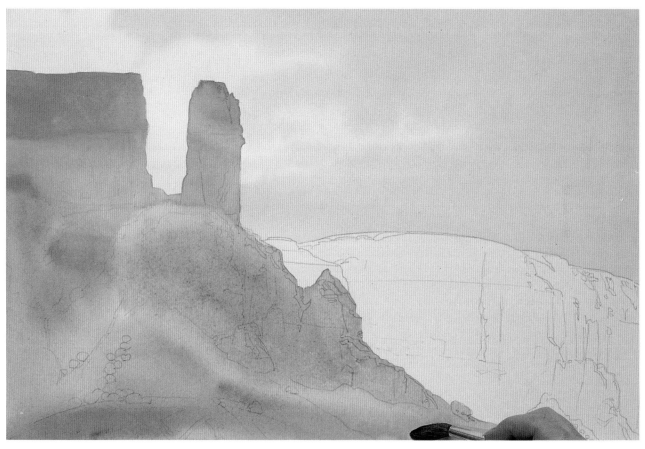

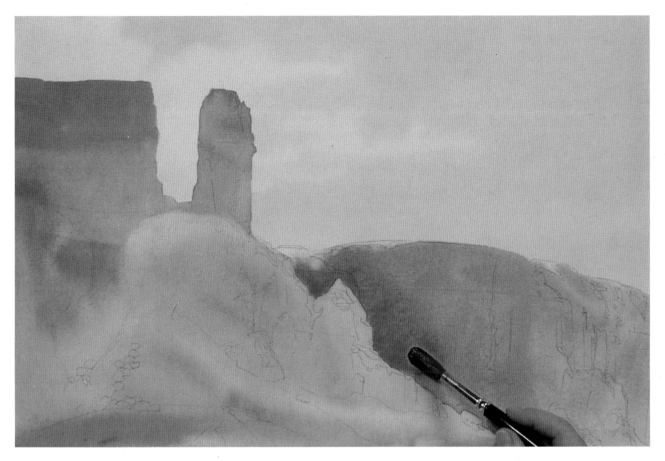

Opposite, below: After mixing puddles of purple, orange, and pink on my palette, I prewet the entire area of the foreground rock formation and begin painting at the upper left, changing color as I proceed down the wash. Because this shape has complicated edges to slow me down, I realize that parts of the prewet area may begin to dry before I can paint the whole wash, which creates a danger of backruns. (I am less concerned about unevenness of color, since the rocks are quite variegated in any case.) I am watchful for backrun formation as I paint, and when I see one developing, as at the base of the vertical erosion feature, I arrest it by touching the area with a squeezed-out, thirsty brush.

I am striving in this wash for fairly smooth transitions among the various colors to create a lively hue base for this very important section of the painting, corresponding to the local color of the rock. I make no attempt at this point to attend to the color or value of the shadow areas. I do exaggerate the colors a little in comparison with the reference photo, realizing that distance tends to dull colors in photography, and also wishing to make the colors as appealing as possible, while still striving for plausibility.

I also paint right over the small green trees, which can be easily superimposed on the base wash later since they are considerably darker. Painting around the trees would endanger the smoothness of the wash.

Above: After mixing a puddle of blue-purple (cobalt blue and quinacridone red), I prewet the background cliff area and paint in a smooth wash. I immediately see that I want to exaggerate the contrast between the edge of the foreground formation and the background cliff. So, while the cliff wash is still wet, I return to it with a more intense brushload of purple. I have made this wash somewhat bluer than the reference photo would suggest, to increase the sensation of distance between the foreground formation and the background.

When I return to the wash for the background cliff with a darker purple for contrast at the juncture with the foreground wash, I create a backrun opportunity because the original wash has been inevitably drying. I prevent the anticipated backrun by quickly employing the hair dryer. The dried wash is variegated, but with soft transitions between values.

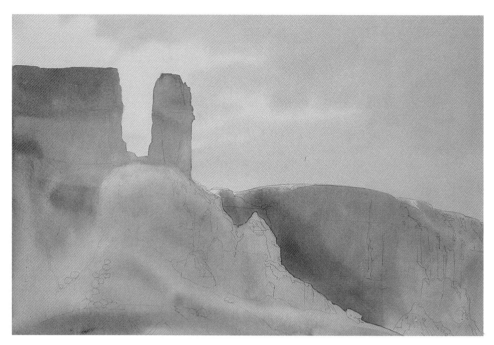

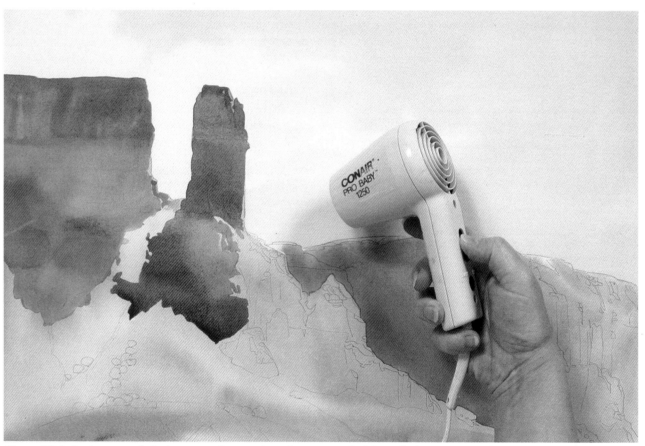

To establish the foreground shadow areas, I proceed one by one with the separate shapes. First I mix puddles of red-purple, blue-purple, and grayed orange (orange plus blue). I charge up three brushes, one for each of these mixes, and have them ready to use. Then I prewet the leftmost shadow area and quickly paint into it, changing brushes when I want to change colors, to preserve the continuity of the

wash. (If I took the time to wash out a brush and charge it up with a different color when I want to make a color transition, the wash would begin to dry while I did that, leading to backruns and ridges of set color.)

I repeat the same process with the shadow for the vertical feature, using the hair dryer at the completion of each section to gain yet further control.

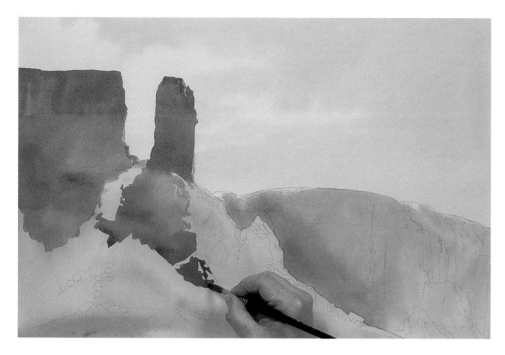

The shadow areas on the smaller rocks of the foreground can be painted directly (without prewetting) with a smaller brush. This will allow for more control over these smaller, intricate shapes.

By this point, the general atmosphere of the painting has been established, and the rest of the process is essentially adding detail and refining the relationships of the colors and values. To paint the foreground moraine, I decide to do some direct, two-handed painting, with a paint-loaded brush in one hand, and in the other, a brush wet (but not dripping) with clear water to soften transitions between lighter and darker areas. Earlier I extended the wash forming the base color of the moraine into the left-hand shadow area to delineate the watercourse by darkening the surrounding areas, but this glaze reduced the contrast between the shadow area and the foreground. To correct this, I'll need to glaze over the lower portion of the shadow area again, increasing the contrast between this area and the foreground.

Above: Here I have intensified the leftmost shadow and refined the shadow areas on the entire foreground formation. As I paint, I keep in mind that objects tend to be darker at the point where they turn a corner (receiving neither direct nor reflected light), and exaggerate this tendency somewhat to enhance the perception of glow in these shadowed rock areas. Note also that the shadows cast by the rock formations onto the foreground are darker and cooler than the parts of the formations themselves that receive no direct sunlight but do receive light reflected off the ground. I have intentionally reduced the amount of detail in the rocks to give the impression of cracks and cavities without losing essential simplicity.

Opposite, above: I complete the foreground detail by adding the pinon and juniper trees along the waterways. Foliage in New Mexico tends toward gray-green, and I exaggerate this characteristic to improve the color harmony of the painting. I make this gray-green by adding a touch of hansa yellow to the purple already mixed on my palette.

Opposite, below: The background cliffs are painted with much less detail than is visible in the reference photograph, and the contrast between the basic wash and the cracks and depressions in the cliff has been reduced. Both changes enhance the sense of distance between the cliff and the foreground formation.

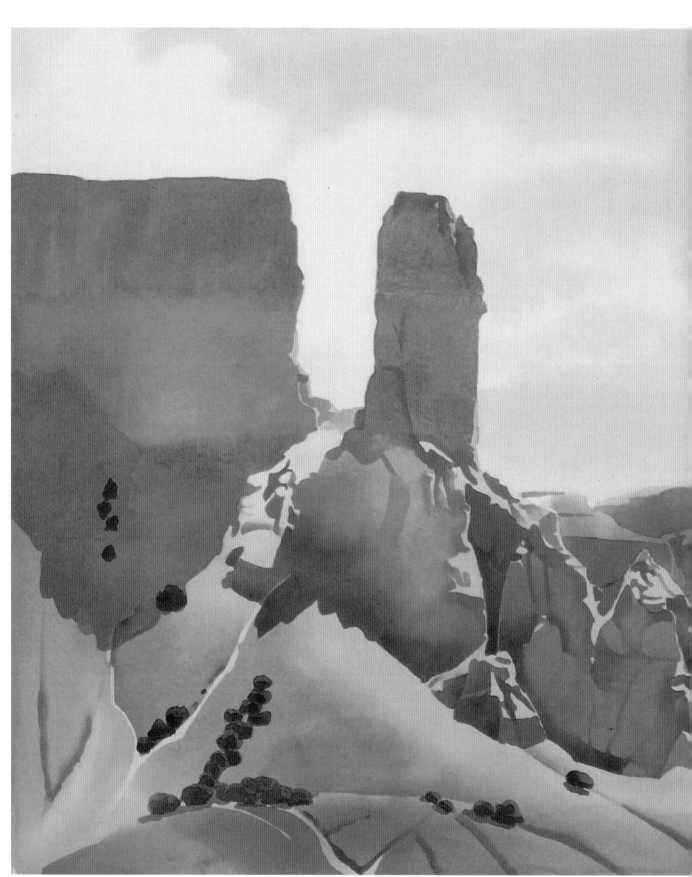

Erosion Feature I by Julia Jordan. Transparent acrylic on d'Arches 140 lb. cold-pressed paper, 15 × 22" (38 × 56 cm). Courtesy of Act I Gallery, Taos, New Mexico.

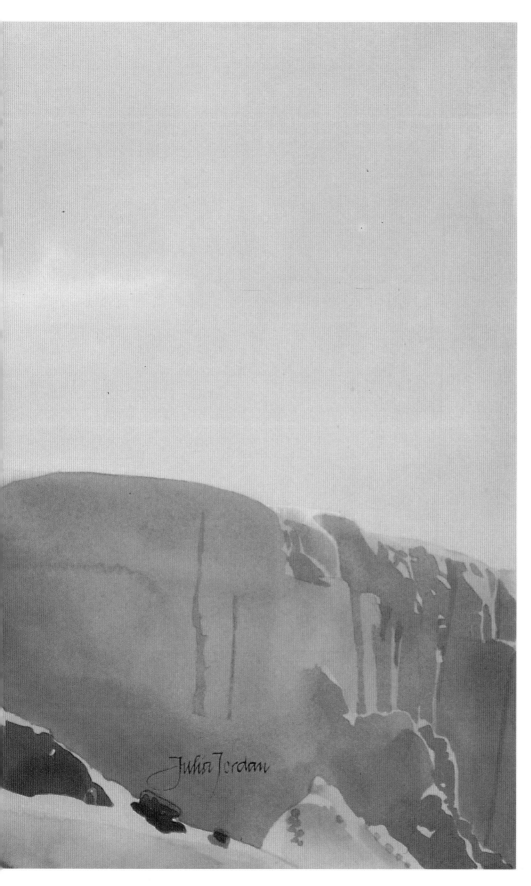

I stand back and scan the painting to check for a balance of color, contrast, and detail, and am satisfied that nothing I could add would improve the piece; so I decide the painting is finished and add my signature.

WATERCOLOR DEMONSTRATION: LANDSCAPE

Watercolor and landscape almost seem synonymous in our minds, because of the long and illustrious history of landscapes in this medium. Surely watercolor is ideal for creating the sensations of atmosphere and light that make many landscape paintings so appealing. In this particular instance, the painting that resulted from my watercolor demonstration turns out to be slightly less satisfying to me than the acrylic version, although this outcome is probably more attributable to the painter than the paint.

One aspect of the paint that did factor in here was that I felt constrained to use phthalo blue to mix my base wash for the purple haze in the background cliff. As a staining transparent pigment, it is less prone to lift off when glazed over. However, because there is a bit of yellow hue in phthalo blue, the purple it creates is less pure than a purple made with, for instance, cobalt blue. I conclude in retrospect that I would have done better to paint this part of the scene in a single, final wash, using cobalt blue and rose madder genuine.

MATERIALS

140 lb. cold-pressed d'Arches paper, 15 × 22"
 (38 × 56 cm), stretched with Zipp Clamps
pencil
3-inch Big Daddy wash brush
1-inch flat brush
numbers 8, 10, and 12 round brushes
John Pike palette
opera (Holbein)
alizarin crimson
rose madder genuine
phthalo blue
cobalt blue
new gamboge
aureolin yellow
water
tissues
hair dryer
rear projection screen (optional)
slide projector (optional)

Here once again, for your reference, is the photograph that inspired the preceding acrylic demonstration and this watercolor one.

The drawing for the watercolor is very similar to that for the acrylic version. I erase some of the pencil lines that I have decided (on the basis of my experience with the acrylic version) represent unnecessary detail. Although erasing abrades the paper somewhat, I use a very gentle pink eraser. The hazard of abrasion bothers me less than the presence of unwanted pencil lines, which can be erased later but tend to be "fixed" somewhat by water.

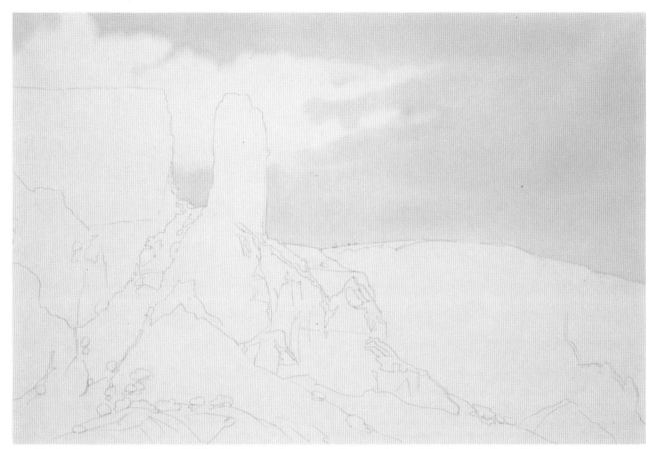

I tackle the sky wash similarly as I did with the acrylic: I mix a puddle of phthalo blue, then prewet the entire sky. This time I make my paint puddle a little richer and squeeze out my brush a little more, because of the tendency of watercolor to flow freely on the prewet area and get out of control.

In spite of my precautions, as I paint around the cloud shapes, I see that the pigment is invading the white area I want to reserve, so when the whole sky wash is complete, I return to the cloud area. With a clean, wet (but not dripping) brush, I paint up to the edge of the blue wash with water.

Because the wash has been drying a little, the clean water I apply to the cloud shapes causes an intentional backrun, defining the edge of the cloud in a "cloudlike" manner.

The danger here is to allow the water to penetrate too far into the blue area, which would create a dark outline around the cloud as the blue pigment forms a ridge at the edge of the backrun. Such an outline would not be visually plausible, so this is a delicate operation. It should be noted that using a backrun in this way would not be feasible in acrylic because of acrylic's fast setting time.

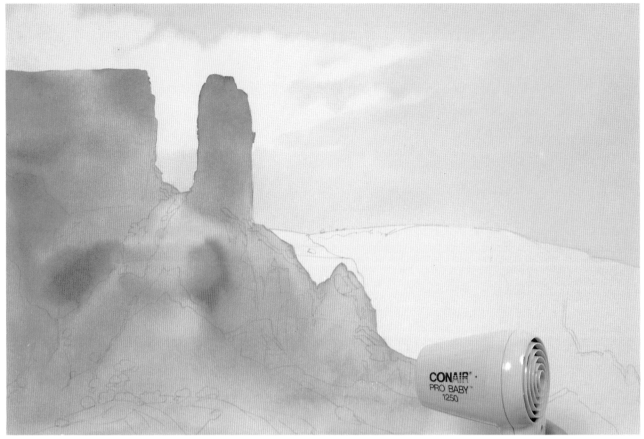

As with the acrylic, I prepare puddles of violet, orange, and pink on my palette before prewetting the foreground rock formation shape. I use staining transparent colors (alizarin crimson, phthalo blue, and new gamboge), which are less likely than nonstaining pigments to be disturbed as I glaze over them in later steps. I have charged up three brushes,

one with each of the colors I want to use in this wash, and to change color I change brushes. It is noticeable that the transitions between colors in the wash are less distinct than in the acrylic version—again, because of watercolor's greater tendency to flow. Finishing with the hair dryer stops any activity that may be changing the image as the wash dries.

I prewet and paint in the background cliff, using a blend of the pigments already on my palette, for a variegated hue. I am not quite satisfied with the color (phthalo blue, because of its slight yellow content, makes a less pure purple than cobalt blue). But I leave it alone for now, for two reasons: As mentioned earlier, the staining pigments are better able to withstand the disturbance of the glazes I plan to paint over this area, and correcting the color with an overall glaze of cobalt blue would darken it more than I want.

A few small flecks of paint have landed on the sky area, and in the photo you see me removing them by "tickling" them off with an X-Acto blade.

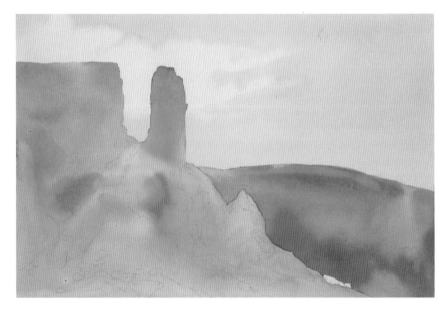

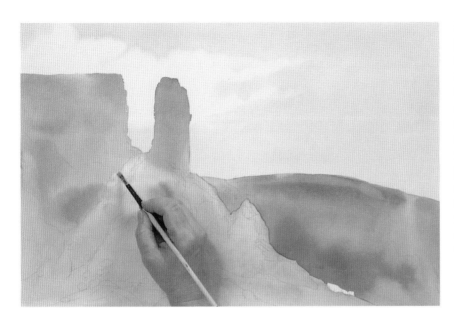

Looking again at the foreground rock formation, I notice that my free-flowing initial wash has excessively darkened an area that I intended as sunwashed, so I lighten this area by scrubbing with a small, stiff-bristle brush dipped in clean water. The staining pigment of the first wash lifts off more than acrylic would, but not as well as nonstaining pigments. There is, however, some improvement. The scrubbing does abrade the paper to the point where it is fortunate that I don't intend to paint over this spot again, or my stroke would have a fuzzy edge.

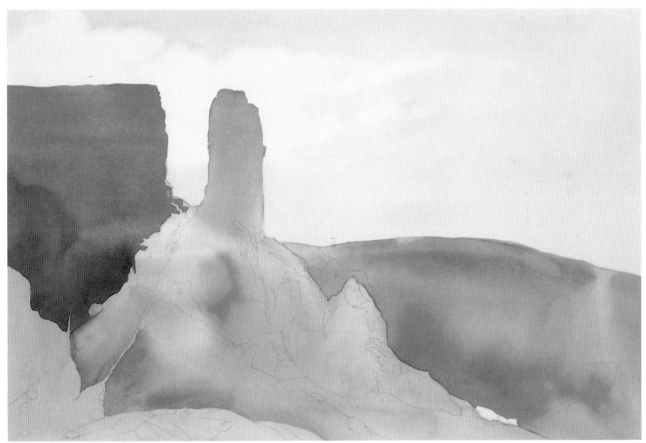

To complete the leftmost shadow area, I decide against prewetting and decide to paint directly. In preparation, I mix fairly intense puddles of nonstaining pigment and charge up three brushes with blue-purple, red-purple, and grayed orange (cobalt blue, rose madder genuine, and aureolin yellow). For the sake of freshness, I want this to be the final wash over this section, hence the intense hues. There is some hazard in this, should I err in my color mixing, but a

mistake is probably no more fatal to the painting than the dullness caused by excessive glazing.

I paint the shadow area as quickly as I can in the interest of making the color transitions as smooth as possible. When I get to the bottom of the shadow area, I drag some of the paint into the foreground moraine area with a clean, wet brush, to delineate some of the watercourse edges. This is done on impulse, since I have a brush well loaded with the right color.

In painting the shadow area of the vertical rock formation, I get a little too carried away with the reddish glow, one of the hazards of intense direct painting.

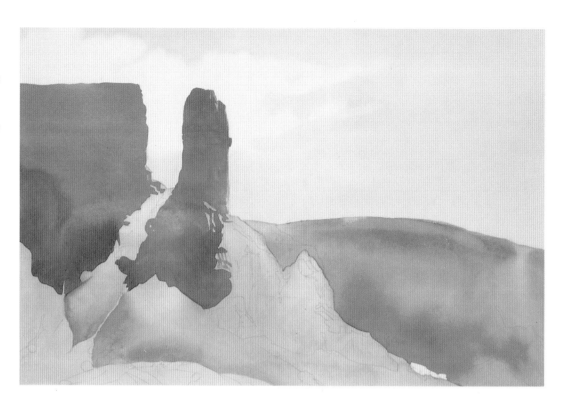

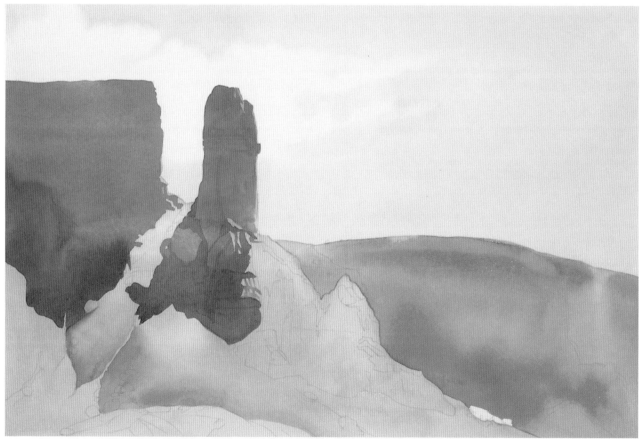

I glaze over the excessively reddish area with quick strokes of purple to represent detail in the rocks, and am comparatively satisfied. A smooth glaze over the area would have been more difficult to do because the underlying pigments might have lifted off while I painted, creating uneven color.

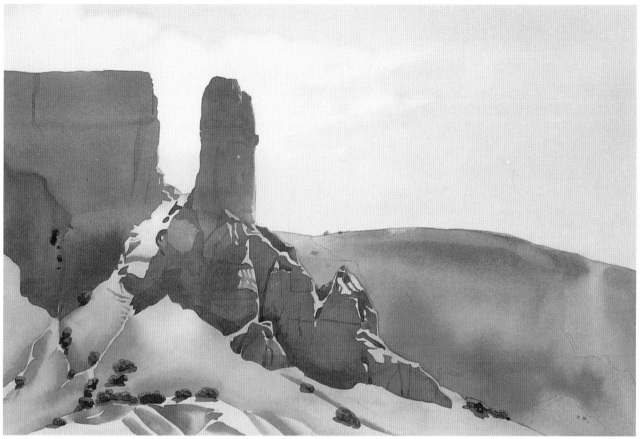

I complete the other rocks and foreground moraine and trees in much the same manner as in the acrylic version. Where the wash representing the foreground moraine meets the leftmost shadow shape, I make the transition with a single stroke of the brush across the shadow's edge. One stroke will not blur this sharp edge, but two would ruin it. I would have been better off painting this area before painting the shadow, but I didn't think of it then. The option of painting up to the shadow's edge would be more likely to produce either a blurred edge or a demarcation between the shadow and the foreground.

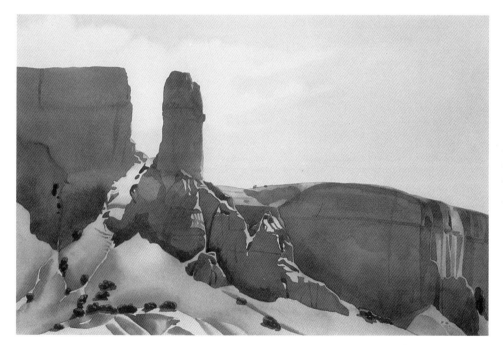

I complete the background cliff, which has become a little darker and less blued than I intended, and lacks the feeling of distance achieved in the acrylic version. I have also added more detail to this area than I actually would like, in order to balance the amount of detail in the rest of the painting. I step back from the painting, decide that there is nothing remaining to be done that would enhance it, and determine that it is finished.

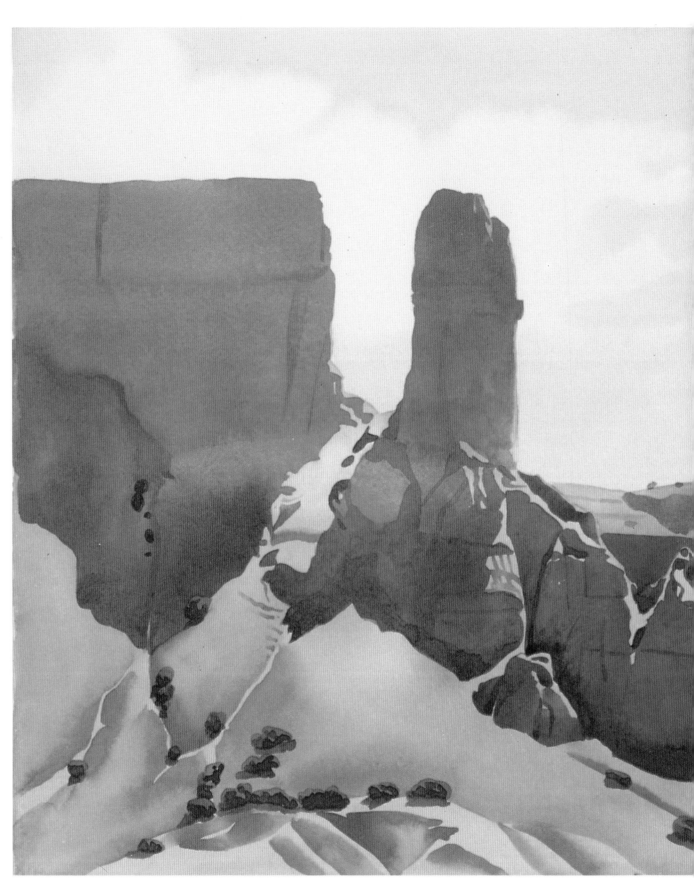

Erosion Feature II by Julia Jordan. Transparent watercolor on d'Arches 140 lb. cold-pressed paper, 15 × 22" (38 × 56 cm). Collection of Frances and Morris Reynolds.

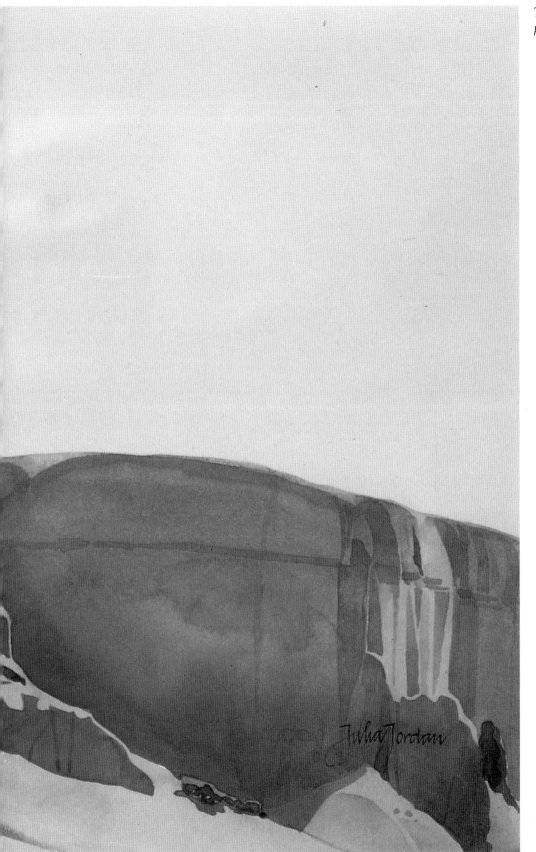

The finished painting.

Ristras for Sale by Julia Jordan. Transparent acrylic on d'Arches 140 lb. cold-pressed paper, 22 × 30" (56 × 76 cm). Private collection.

WHEN THE PAINTING IS DONE, WHAT NEXT?

Sometimes the greatest dilemmas in the process of making art arise when a painting has been finished: Now what? It is at this point that the painter is forced to consider the purposes of painting. Is your work to be framed and displayed, or destroyed, or stored in a closet? Do you plan to keep it, give it away, exhibit it, or sell it? The answers to these questions can be discovered only by the artist, but when they are known, this chapter hopes to help with some of the practical considerations that follow.

MATTING AND FRAMING

To be displayed, works on paper should be framed under glass (or acrylic glazing) with a spacer, such as a mat, between the painting and the glass. The glazing is to protect the paper and the paint surface from dirt and other pollutants that would be impossible to clean off without damaging the painting surface. (Oil and acrylic paintings on canvas, by contrast, can be cleaned.) The mat is to separate the painting surface from the glazing surface. It is particularly important to keep watercolors from touching the glazing material, lest humidity should creep into the frame and dissolve watercolor pigments, causing them to stick to the glass. Paintings may also be "floated," without the use of a mat, by attaching them to backing board and providing a spacer in the frame between backing board and glazing.

Professional framers take the position that matting and framing are in themselves esthetic undertakings, and some aspire to enhance works of art with the mat and frame. My attitude tends more toward the Hippocratic position: First, do no harm. In other words, mat and frame should not *interfere* with the esthetic qualities of the artwork. The functions of mat and frame are primarily to protect the piece and make it possible to display it on a wall. Beyond that, I feel that they should be visually pleasing but unobtrusive.

THE FRAME

If you do your own framing, the easiest and least expensive frames to use are metal sectional frames that are joined at the corners by metal brackets and screws. Metal frames are available from art supply dealers, frame shops, catalogs, and manufacturers who advertise in artists' magazines. These frames come in metallic and enameled surfaces and a wide range of colors. Advantages of metal frames, in addition to low cost and ease of assembly, are that they are almost always accurately chopped, they are easy to reuse with another painting, and they don't require either backing paper or any equipment other than a screwdriver. Disadvantages are that if paintings in metal frames are transported (to shows, for example), they are easily scratched and after several moves may begin to look shopworn. Most important, many collectors prefer wood frames.

Recently sectional wood frames have come onto the market that are nearly as inexpensive as metal frames. Possibly because the manufacturing techniques are still in their infancy, I have found that these frames too often have corners that don't match perfectly or are not properly grooved to receive the plastic insert that helps stabilize the corner. If the frames have been ordered from a manufacturer or catalog, it is a headache to send them back, and this sort of problem always seemed to arise just as I was frantically preparing for a show or gallery delivery.

Another option for relatively economical framing with wood is to find a framer willing to work with you and provide just the assembled frame, according to your specifications. You could then do the matting and assembly yourself.

Finally, for the sake of completeness, I should mention that ready-made wood frames can be bought from wholesalers and frame shops. These tend to come only in standard sizes (9 × 12", 16 × 20", 18 × 24", and so on) and are usually rather old-fashioned and elaborate in design.

For wood frames, some means is required to hold the painting with its mat and backing board in place: either nails or glazing points or framer's points (more on these tools below). Also, the back should be covered with kraft paper to keep bugs, dust and other pollutants from creeping in and harming the painting, and to present a more professional appearance.

The back corner of a metal sectional frame.

The back corner of a wood sectional frame.

Having tried all these options, I confess I have come to a parting of the ways with all my framing tools. I now take my paintings to a framer, select the molding and the matting materials, and let the framer do the work! While this is a great relief, it was several years before I could afford to do it, and in the meantime metal frames worked best for me.

THE MAT

The mat is a sort of thick paperboard that is cut out in the middle to surround the painting. That sounds simple, but expert mat cutting is not. Traditionally, the mat is cut with a beveled edge, which requires a special tool. Mat cutters range in price from $10 to $1000! Of course, the less expensive the tool, the more skill and patience are required to use it effectively. The C & H cutter I have used for years cost several hundred dollars, and though it has ultimately saved me much more than it cost, you should consider your volume of output in deciding whether such a purchase would be economical. The hand-held cutters that are quite affordable tend to result in rather unsteady-looking cuts, and badly cut mats tend to be associated in viewers' minds with less-than-serious painting. I will not attempt to cover the techniques of mat cutting here, because they depend directly on the tool being used. One suggestion I can offer: If you can make friends with one or more framers, they may be willing to let you watch them work and to answer questions. This is what I did, and it made all the difference in the professionalism of my mat cutting.

There are ready-made mats available from catalogs (such as Dick Blick), and sometimes framers will have a selection of precut mats. Like the ready-made frames, ready-made mats tend to come only in standard sizes and don't, in my experience, have the appearance of quality found in hand-cut matting. Precut mats are generally not acid-free either, and this means that your expensive rag paper could be contaminated by the mat and begin to turn brown within months of framing.

As with frames, you could deal with a framer to make mats to order, and still save money by doing the assembly yourself. Also, framers will sometimes offer a special price if mats or frames are ordered in quantity.

Mat board comes in two-ply and four-ply thicknesses, with four-ply being the most commonly used. In recent years Crescent, the foremost manufacturer of mat boards, has begun to add buffering to its regular mat board and advertises it as being acid-free. Theoretically, you should no longer see paintings turning brown because of the matting; but, as with the buffered watercolor papers, buffered matting has not undergone

My C & H mat cutter. The bevel-edge cutter is on the left side of the bar, which is lifted with the handle bar to the left. The cutter is the device on the bar in the foreground, which runs along the rod in the center of the bar. On the right side of the bar is a straight-cutting edge. The cutter also has a blade on this side. The device behind the cutter on the bar is a stop, which is positioned so that the cuts begin and end in the proper place on the mat board. A piece of mat board under the mat being cut is essential for a smooth slice.

the test of time and should be used with caution. Professional artists generally use 100 percent rag matting, which is of the same quality as the paper used for the painting and has a concomitantly high price. Ideally the backing board on which the painting is mounted, as well as the tape used to mount the painting, should also be acid-free. A painting that has been matted with all-rag mat board, and mounted on rag board, using acid-free linen hinges, can be said to have been framed to archival or conservation standards.

GLAZING

Most paintings seen in galleries are glazed with regular window glass, 1/8 inch thick. Glass has the advantage of being inexpensive and easy to maintain, as long as it doesn't break—and there's the rub. If

paintings are to be handled a great deal or transported from show to show, or shipped by a gallery to a purchaser from out of town, the glass may break and cause a major headache. The primary consideration here is to protect the painting itself from being damaged by broken glass. Here the most effective measure to protect paintings to be transported is to criss-cross the glass surface with strips of masking tape, in hopes that if the glass breaks the tape will hold it together and prevent it from gouging the painting. There is also a paper film called Glass Skin available from Airfloat Systems (see List of Suppliers), which is similar to the backing paper on acrylic glazing. Although I have not tried it personally, it might be easier to use and provide greater protection than masking tape.

A further disadvantage to glass is its weight, which with a large painting can be considerable. The larger the piece, the more important it is that the frame be strong enough to hold the glass without bowing at the bottom or separating at the corners. The wire used to hang the painting and the hook in the wall should also be strong enough to hold the weight of the frame and glass securely. Consider also your own physical strength and ability to handle large glazed paintings that you may be carrying to shows or galleries. Finally, I have had the experience of a large piece of glass breaking under its own weight while I was assembling a painting. This experience convinced me to use acrylic to glaze

Plastic cleaner and scratch remover for acrylic glazing. I'm sure there are other brands, but this is the one available to me.

all my work larger than a half sheet. However, I was later given a clue by a glass magician that you may find helpful. This master glass cutter confirmed my perception that glass is very unpredictable in its stability, and this is apparently because of its unorganized molecular structure. Apparently you have a better chance of keeping a large piece of glass intact when holding it horizontally if you place your hands at *diagonal* corners. When storing or transporting paintings framed with glass, keep them vertical, as glaziers do when transporting large panes of glass on the sides of their trucks.

An alternative to glass is acrylic glazing (the most common brand is Plexiglas). The advantages of acrylic are its comparative lightness, its unbreakability, and the fact that it screens ultraviolet rays and helps protect the painting from sunlight. The disadvantages are that it costs two to three times as much as glass, scratches easily, and is prone to static electricity. It is for the latter reason that framers often resist using acrylic, because the static electricity attracts mysterious flecks with devilish persistence. You are likely to find one or two underneath the glazing after the frame has been put together, no matter how careful you have been.

A cure for "debbils" (my personal name for those flecks) is the spray antistatic plastic cleaner available in

The glass in this frame has been taped to prevent damage to the art if the glass breaks in transit.

glaziers' shops. The downside to this stuff is that it can leave a greasy-looking film on the acrylic that is very persistent. The cure for *that* headache is to spray the cleaner on a soft, lint-free cotton cloth and then wipe the acrylic, rather than spraying the cleaner directly on the glazing. This applies enough solution to clean and control static without leaving a residue. (Incidentally, this technique also makes interior window and mirror cleaning much faster. I learned it from a hotel maid!) Beware of using paper towels or glass cleaner on acrylic, because they will dull it. There is also a scratch remover and polisher that will help with quite shallow scratches and abrasions on acrylic, but the best cure for scratches is prevention. When transporting acrylic-glazed paintings, always wrap them in plastic sheeting or some other protective cover, and never lean paintings against each other.

One disadvantage shared by glass and acrylic is that they are reflective. Depending on the location and nature of the light source, reflections may interfere with viewing the painting. Sometimes artists, framers, and buyers try to circumvent this by using nonreflective glass. Unfortunately, the original nonreflective glass also interferes with the clarity of the image behind it, and most professional painters avoid it like the plague. There is a new kind of nonreflective glass on the market (one brand is called Denglas) that does not have this disadvantage. I understand that it is quite expensive, but for a major work of art the expense would seem to be justified. I have seen it in museums, upscale galleries, and exhibits of master paintings, and its effect is quite remarkably like that of invisible glass.

ASSEMBLY

The first logical step is to assemble the mat, backing board, and painting. Hinge the tops of the mat and the backing board on the inside at the top, using tabs of acid-free linen tape. The kind that needs to be moistened to become sticky seems easiest to use. Do not wet the part

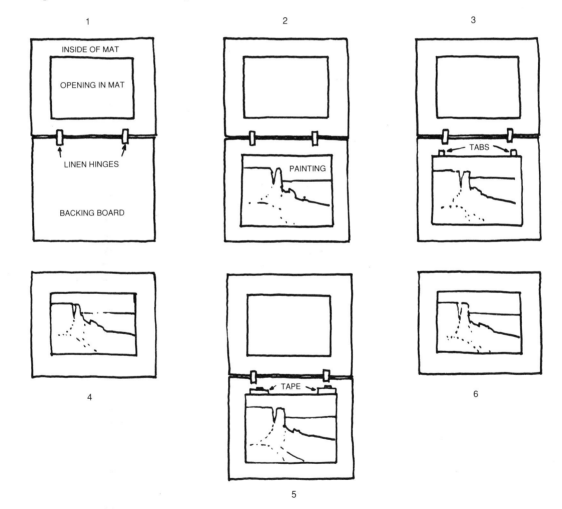

To assemble the mat-and-painting package, follow these steps. (1) Hinge the top edge of the inside of mat to the top edge of backing board, using gummed linen tape. (2) Tentatively position the painting on the backing board. (3) Attach gummed linen tabs to the back of the painting, so that about *1 inch of tape protrudes from the top. Do not moisten the part of the tape that protrudes. (4) Close the mat to check the placement of the painting, and reposition as necessary. (5) Use gummed linen tape to attach the tabs to the backing board. (6) Close the completed mat-and-painting package.*

When assembling a mat, use acid-free linen tape to hinge the top of the mat to the top of the backing board and to hold the top of the painting in the correct position. Note that the painting hangs freely inside its "sandwich" and can expand and contract without buckling.

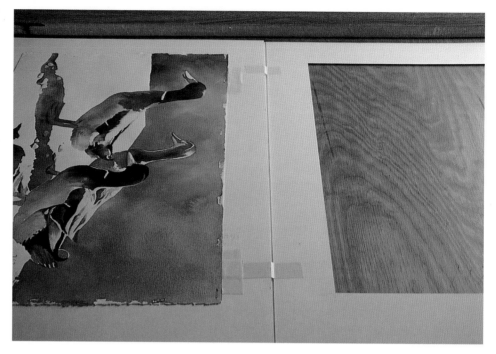

Here is a metal frame, partially assembled. The top and sides have been screwed together, the unit of glass/painting/mat has been slid into the grooves, and the wire has been attached. All that remains is to screw on the bottom piece of the frame, insert the spring clips that keep the glass from rattling, and clean the glass.

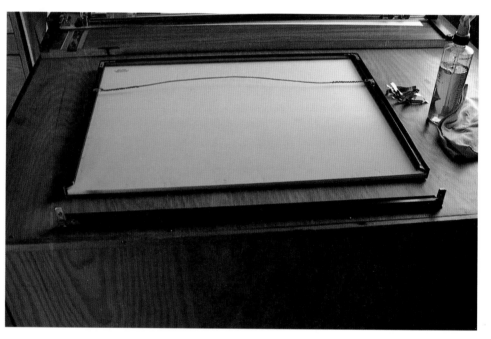

that will protrude from the top of the painting. Lay the joined mat and backing board open on a roomy work surface, and position the painting roughly in the center of the backing board. Next attach tapes to the top back of the painting, so that about 1 inch of each one, gummed side toward you, protrudes from the top of the artwork. Two or three tapes are usually sufficient.

Before sticking the tapes to the backing, position the mat over the painting and backing, and make sure they are in the proper relationship. Then raise the mat and use pieces of tape to attach the tabs on the painting to the backing board. This procedure allows the painting to hang free behind the mat and prevents it from

buckling should humidity cause the paper to swell. The mat does not have to be attached to the backing with tape hinges at the top, but I find it makes for easier handling. Also, should the painting be removed from the frame or shown unframed, the mat should be attached.

Next, prepare the glass or acrylic glazing by cleaning *one* side. With acrylic, a protective paper must be peeled off. Although the acrylic is sparkling clean at this stage, pulling off the paper will arouse its static electricity demons, so it is advisable to wipe the peeled surface with a cloth sprayed with antistatic plastic cleaner, and polish it with another cloth. Immediately

place the clean side of the glass or acrylic over the mat, before any debbils can get between them.

Prepare the frame to receive the glazing and mat (which should now be handled as a unit until assembly is complete, for debbil prevention). If you are using a metal frame, attach the top bar to the two side bars and insert the holders for the wires. Then slide the glazing-and-mat into the three-sided frame. If you are using acrylic, peel off the paper on the outward side just before this step, and check for debbils. Before attaching the bottom bar of the frame, again check for debbils between the mat and the glazing. Then go for it. When the frame is assembled, push the spring clips that come with the hardware between the backing board and the inner lip of the frame, to hold the glass-matting package securely in place. Then attach the wire, and the frame is ready to go, except for cleaning the glazing on the outward side. There's no point doing this before you are finished handling the piece.

Wood frames should be completely assembled before you add the glass-plus-matting, and the glue allowed to set thoroughly. Lay the frame face down on your work surface, and place the painting package (that is, glazing-plus-matted-painting) in it face down. Holding the package in place with your fingers, turn the whole thing up so you can make a final inspection for debbils. (If you find them later in the process, you will be *annoyed!*) With the frame face down again, you will need to secure the painting package in the frame somehow. The best implement, and well worth the approximately $60 price, is a Frame-Master framing tool. I have tried a device that squeezes brads into the frame, as well as a glazier's point shooter, and I can testify that the happy framer uses the Frame-Master. Shoot framing points into the frame flush with the backing, every 2 inches or so all the way around. When this step is done, once more check for debbils. After this it will just be too much trouble to exorcize them.

Cut a piece of heavy kraft paper (available at art supply stores and frame shops) to be a couple of inches larger than the frame all the way around. Attach

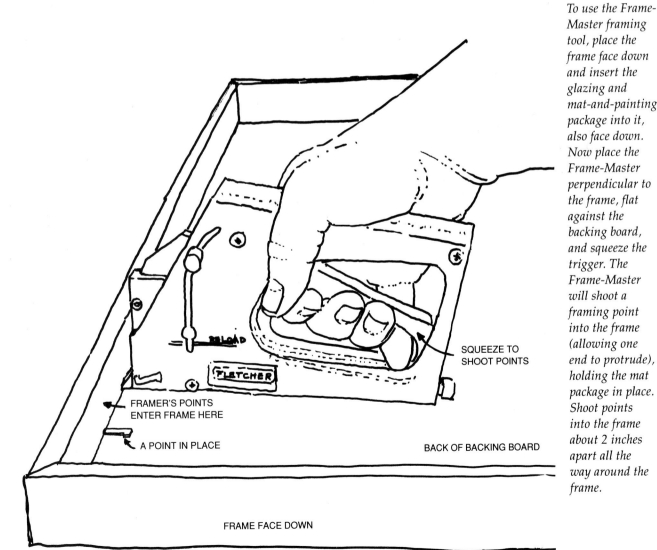

FRAMER'S POINTS
ENTER FRAME HERE

A POINT IN PLACE

RELOAD

FLETCHER

SQUEEZE TO
SHOOT POINTS

BACK OF BACKING BOARD

FRAME FACE DOWN

To use the Frame-Master framing tool, place the frame face down and insert the glazing and mat-and-painting package into it, also face down. Now place the Frame-Master perpendicular to the frame, flat against the backing board, and squeeze the trigger. The Frame-Master will shoot a framing point into the frame (allowing one end to protrude), holding the mat package in place. Shoot points into the frame about 2 inches apart all the way around the frame.

Here I am applying adhesive to the back of the frame with a Scotch adhesive transfer gun (ATG). The ATG is a broadly useful tool.

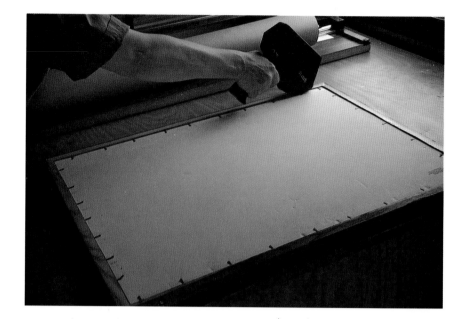

Here you see the ATG in more detail, first closed and then opened up to show how it works. The adhesive is backed with a strip of waxed paper. When the adhesive and backing are rolled up on spool 1, the adhesive is touching nothing but waxed paper or air, keeping it from sticking to anything before it makes contact with the desired surface as it passes over roller 2, which protrudes when the gun is closed. After the adhesive is removed from the the backing at the point of *contact, the empty waxed paper strip rolls back over the top of the adhesive roll and is wound up on spool 3.*

As it is rolled along, with the trigger depressed, the ATG lays down an even line of adhesive that is sticky on both sides—like double-stick tape without the tape. The adhesive will bond firmly, but if bonded surfaces are pulled apart, the adhesive can be removed cleanly using a gum rubber pickup such as the one used for removing dried masking fluid.

adhesive to the back edge of the frame. By far the easiest to use is double-sided tape dispensed by an adhesive transfer gun (ATG), but double-sided tape from a roll, or even glue, would theoretically work. Unroll the kraft paper over the back edge of the frame, pressing it against the adhesive. Then, with an X-Acto knife, cut away the excess. (Believe me, this is much easier than cutting the kraft paper to the exact size of the frame and trying to make it fit!)

This is the traditional way of attaching backing paper to a frame, and it has one disadvantage: There is usually an airspace between the backing board and the backing paper, allowing the backing paper to be easily punctured or torn. Such damage obviates both the esthetic and practical purposes of the paper backing. To eliminate the airspace on deep frames, cut the kraft paper 3/4 inch wider on each side than the interior

measurements of the frame (that is, than the size of the mat/backing board). Cut out 3/4-inch squares at each corner of the kraft paper, and fold over the 3/4-inch lips just created. Apply adhesive to the folded-over lips on the kraft paper. Drop the kraft paper, with the folded edges uppermost, into the back of the frame. It should be a pretty close fit. Press the folded-up edges against the inside wall of the frame. I have only one reservation about this approach that I feel conscience-bound to mention: I don't believe kraft paper is acid-free, and over an extended period of time it is possible that the backing board could be contaminated with acid. However, if a four-ply rag mat has been used as backing, my own judgment is that the amount of contamination thus generated would be little more than if the painting were left open to the air, or covered by a torn or punctured backing paper.

The next step is to unroll kraft paper over the back of the frame. It is easier to achieve correct placement by unrolling the kraft paper; just make sure the first edge is parallel to the frame edge, and both sides overlap the sides of the frame. Press the kraft paper down onto the adhesive as you unroll it.

An X-Acto knife makes it easy to cut away excess backing paper to the precise dimensions of the frame.

Preparing kraft paper backing for a deep frame. (1) Measure and cut a piece of kraft paper 3/4 inch (2 cm) larger than the mat-and-painting package all the way around. That is, if package measures 16 × 20" (41 × 51 cm), cut kraft paper to 17 1/2 × 21 1/2" (45 × 55 cm). Cut a notch about 3/4 inch deep on each corner. (2) Bend up the edges to a depth of 3/4 inch, and apply adhesive to the folded-up edges, all the way around. (3) Place frame containing secured mat-and-painting package face down. Then drop the kraft paper into the cavity at the back of the frame, with the sticky edges of the paper facing the inside walls of the frame. Finally, press the edges of the kraft paper against the walls of the frame.

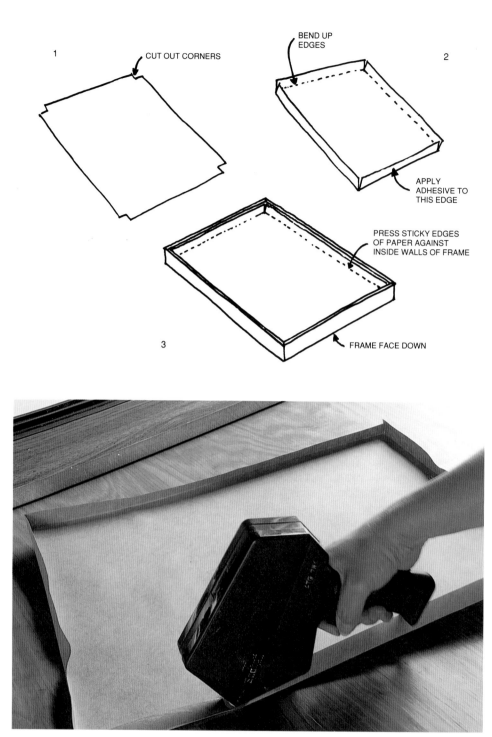

1 CUT OUT CORNERS

2 BEND UP EDGES

APPLY ADHESIVE TO THIS EDGE

PRESS STICKY EDGES OF PAPER AGAINST INSIDE WALLS OF FRAME

3 FRAME FACE DOWN

Here is a piece of kraft paper measured and shaped to be dropped into a deep wood frame. I am applying adhesive to the edge that will contact the inside of the frame.

The last step in assembly is attaching the wire. Mark the place where the wire-holders should go (I place them six to eight inches from the top of the frame) and drill a hole for each. Make sure the drill bit is a little smaller than the screws that will be used, or the weight of the painting could pull the screws out of the frame when it is hung on the wall. Attach the wire-holders with screws that have been rubbed with soap to make them go in easily and reduce the risk of splitting the frame. Then attach the wire, and all that is left to do is the final polish on the glazing.

The safest place to store framed paintings is on a wall. If they must be stored elsewhere, keep the paintings upright. Protect the frames, glazing, and backing paper from damage by sliding pieces of cardboard or foam rubber between the paintings.

Unframed paintings should be kept flat, dry, and away from acidic materials and other pollutants. The simplest method is to keep finished pieces in portfolios and separated from acid-bearing materials (such as the cardboard of which many portfolios are made) with sheets of acid-free barrier paper.

Measure and mark the position for wire-holders, making sure you are placing the marks at the top of the painting. (Here I am carelessly drilling holes at the bottom of the painting. I later cover these holes with small patches of kraft paper.)

Any brand of liquid soap, applied to the screws for the wire-holders, makes the screws easier to insert and prevents cracking the wood of the frame.

The finished frame back.

PHOTOGRAPHING ARTWORK

It is a good idea to have a photographic record of all your work, both for personal historical purposes and for professional purposes. The most useful and economical form of photography is the 35mm slide, from which prints may be made if needed. Slides will be requested by galleries where you would like to show your work, for jurying into exhibits and competitions, and by potential patrons.

I won't attempt to teach photography here; books on photographing artwork are available and can be very helpful. What I can do is share some hints I've picked up over the years on solving photographic problems peculiar to water media painters.

I have also taken every opportunity to ask professional photographers questions about their craft, usually in the context of their taking photographs for me when it seems an especially high standard must be met (such as for this book).

Unquestionably, the easiest time to photograph a watercolor is before it is framed. Both glass and acrylic glazing materials are highly reflective, which makes it very tricky to get a clear shot of a painting underneath. However, in a pinch, it *can* be done: Get a full sheet of black mat board and, in the center, trace around the lens of your camera. Using an X-Acto blade, cut out a hole that will fit over the camera lens snugly. Mount your camera on a tripod and fit the hole in the mat board over the lens. It should be sufficient to steady the board with your hand, or you can get someone to help you hold it while you take your pictures. The black mat surrounding your camera lens will not be reflected in the glass of the painting, and should be big enough to prevent any other objects from being reflected.

In a sunny climate it is easiest to take photographs outdoors, choosing a time that is not windy. Avoid high noon, when the light will wash out colors; cool early morning light or warm late afternoon light is best. Using double-sided tape (most easily applied from an adhesive transfer gun, or ATG for short), stick your unmounted painting in the center of a black or neutral gray mat board that is either affixed to a wall or stood perfectly vertically on an easel. If an easel is used, a piece of board may be needed to stiffen the mat board; the setup needs to be vertical and flat. Place the painting completely in the shade (under an overhang or on the shady side of a house) but facing a sunny place. The light that illuminates the piece will thus be reflected sunshine. Make sure the light is not dappled, because that will show in your photograph. Any strong colors in the area reflecting the light will cause color effects in the photograph, so take that into account.

A tripod will help keep your camera steady, but it is possible to use a handheld camera. A single-lens-reflex (SLR) camera is preferable, because what you see in the viewfinder of the camera is what you get in your photograph. With a rangefinder camera, your viewfinder may be slightly off from the camera's lens. This is important, because it is desirable to fill the viewfinder as closely as possible with the painting itself. The less border is showing, the better the composition of the shot. It is very important to avoid any extraneous objects or patterns in the photograph of your painting; they compete with your carefully thought-out composition, and as such are denigrating to the work of art. It is also important to have the camera squarely facing the artwork; when you look into the viewfinder, its edges should be parallel with the edges of the painting.

Professional photographers "bracket" their shots of paintings, which means they take one shot that is their best estimate of correct exposure, one that is slightly underexposed, and one that is slightly overexposed. Bracketing helps compensate for the fact that a painting with strong contrasts may be difficult to shoot with complete accuracy. Many of us ordinary mortals, if we are fortunate enough to own a good SLR camera, will have one that is hopelessly automatic. F-stops and exposure time are determined by the camera, and we can't control them; so how can we bracket? I learned a trick from a photographer friend that works pretty well: manipulate the ISO setting. The ISO setting is the indicator of the speed of your film. If you have ISO 100 film in the camera, you could take one shot at ISO 100, one at ISO 200, and one at ISO 50 or 64. This "fools" the camera into bracketing, despite its automatic exposure mechanisms.

My current camera is a Canon EOS 650, which has a unique feature I'd like to share with you: It has a setting for "depth," that is, depth of field. It allows the photographer to focus on two places for one shot, and the camera will adjust everything (focus, f-stop, and shutter speed) so that everything between the two focal points is in focus and properly lit. That's great for photographing certain objects and people and landscapes, but it's *fabulous* for photographing paintings. In photographing a flat painting, depth of field is not really relevant. However, by using the depth-of-field feature on two areas of a painting that are extremely different in value and color, you get two readings of the different light data available on that flat surface. This makes the camera average out light readings to provide a more accurate f-stop and shutter

speed setting for the painting as a whole. Since making this discovery, I have given up bracketing, saving quite a bit of money since I don't have to pay for film and developing of images that are less than perfect.

To take photographs indoors, you will need a more elaborate setup, but indoor shots are possible when the weather is impossible. Daylight film, which is color-balanced for cool outdoor light, will produce reddish photographs under incandescent (indoor) lighting. For indoor shots, use tungsten film (Kodak Ektachrome Tungsten or Fujichrome Tungsten are most often recommended). To illuminate the piece of art evenly, shut out extraneous light sources and set up two lamps at 45-degree angles to the piece, which should be mounted on a wall or some other vertical surface. The most effective bulbs to use are 500-watt photofloods that produce 3200K light, for which the tungsten film is balanced. Lamps, bulbs, and tungsten film are usually available only from stores catering to professional photographers.

Setup for photographing paintings indoors. (For photographing outdoors, eliminate lamps.) Attach the painting to a board covered with gray or black paper, using low-tack adhesive on the back of the painting. (An adhesive transfer gun, or ATG, works well for this.) Stand the board on a vertical easel, or attach it vertically to a wall.

Place the camera on a tripod so that the center of its viewfinder is focused on the center of the painting and the painting fills the whole viewfinder. The camera should be parallel to the painting. Photoflood lights should be on either side to the rear of the camera, each at a 45-degree angle to the painting.

SHOWING YOUR WORK

It is easy to see why a beginning painter might feel some inner conflict about showing his or her work. On the one hand, why paint, if not to show the image to others? On the other hand, if you show your work, it invites criticism. To find a supportive context in which to show work and get some sympathetic feedback, you might consider attending art clubs and watercolor societies. It is often difficult to locate such groups, because they seldom can afford a listing in the telephone book. One way is to check the activities calendar of your local newspaper, and another is to look at *American Artist* magazine's semiannual publication on watercolor. The spring issue generally lists most of the watercolor groups in the country. Art clubs have regular meetings where there are often demonstrations by expert painters, who will sometimes comment on paintings brought in by members. Sometimes awards are offered for the paintings members bring to regular meetings. Most clubs will sponsor periodic exhibits, which will be juried by well-known artists. It takes courage to submit a painting or slide for jurying, but even a rejection can be a learning experience. Over time, the proportion of rejections and acceptances is likely to improve, and the change is a measure of your progress. Remember, even the most successful artists are rejected occasionally, and this is an indicator that jurors' personal tastes often determine whose work is chosen. Rejection may not mean the painting has no merit; a painting rejected by one show could win a prize at the next! I often say I don't know anything about art, I just know what I like. And I suspect that is true of many jurors as well.

I think it is also important to take with a grain of salt any critique offered on a painting. "Experts" often have prejudices that are pronounced with the conviction of universal law, such as, never put the center of interest at the center or edge of the painting; never place complementary colors next to each other; always place complementary colors next to each other; cool recedes, warm advances; and so on and so on. If the comments seem helpful, use them. If not, ignore them. Follow your own nose; don't let every expert or teacher you encounter jerk you around (including this one)!

As you become more confident in showing your work, it may be tempting to expand beyond the local art group and enter juried shows at a distance. If you belong to a club or society, you may begin to receive unsolicited prospectuses about exhibits and competitions from art groups in other cities, because you are now on a mailing list that has been shared. Another source of information about shows to enter is artists' magazines, such as *American Artist* and *The*

Artist's Magazine. They both have a monthly listing of major shows and requirements for entry.

One thing to keep in mind when deciding what shows to enter is that entry fees are often relied upon by art groups to pay the expenses of mounting an exhibition and awarding cash prizes. These are legitimate expenses in most cases, but if very many people enter and relatively few can be chosen, your entry fees are subsidizing a show in which you have a low probability of actually participating. Another consideration in entering shows at a distance is the expense of being accepted. The painting must be crated and shipped, there is often a handling fee in addition to the entry fee, and the painting may be unavailable to you for months or even over a year. There is the possibility that the painting will be lost or damaged in transit, and craters and shippers accept only limited liability for original works of art. If, having considered the costs, you decide to enter juried shows out of town, here are some hints to reduce the cost and risk involved.

Most shows now require that shipped paintings (and sometimes *all* entries) be glazed with acrylic to avoid breakage in transit and during the hanging of the show. If you think a piece may be accepted for an exhibit, you may want to use acrylic glazing from the outset. Even if not required, acrylic glazing improves the chances that your piece will arrive at the exhibit in good condition.

There are professional crating companies that make wood and/or fiberboard crates that will withstand even brutal treatment. Homemade crates are much less expensive, if your abilities run in that direction. Wood crates tend to be quite heavy, so in addition to the cost of the crate (up to $100), the cost of shipping will be proportionate to the weight. This can add another $100 or more to the cost, assuming the piece will make a round trip. Alternatively, I have had consistent success with a reinforced and padded cardboard crate called a Strongbox (see List of Suppliers for source), which costs perhaps half as much as having a wooden crate made and also costs much less to ship. Several that I still have in storage have made several trips and are still usable.

Shipping companies have various requirements for handling original art. For example, some shippers will not accept glass or insure original artwork. If the piece is insured, there must be evidence on the value of the work of art before you can collect damages, which is tricky if you do not have a proven record of consistent sales.

Some provision is generally required for shipping the piece back to you after the show is over. You may

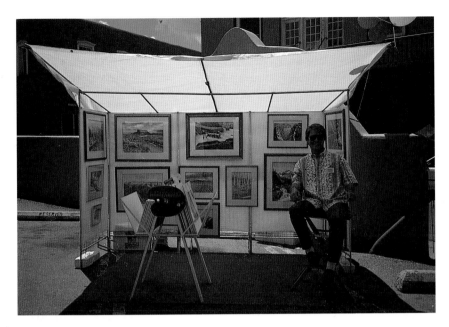

Artist Dennis Taylor shows off his outdoor exhibit setup. The framework breaks down for easy transport. The white cover protects him from sun, wind, and rain without distorting the colors of the artwork. The framework is tied down to cement blocks to protect the whole thing from blowing over—a sad sight indeed, which occurred not ten yards from where this photo was taken! Dennis sits on a high bar stool, allowing him to be comfortable and at the same time make eye contact with browsers. A bin contains matted pieces that are shrink-wrapped to protect them from finger marks and from the elements. Attached to the bin is a sign with his name and medium: watercolor.

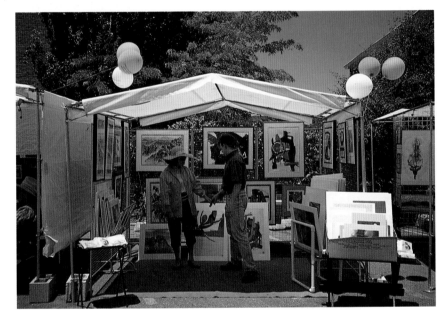

Artist Sueko Yamada, wearing a wide hat for protection from the sun, chats with an interested browser. She uses a framework similar to Dennis Taylor's, but somewhat larger. She further increases her exhibit capacity with three bins, plus a folding table for notecards.

have to enclose a check for the amount it cost to ship the painting *to* the show, to cover its return. It is much easier to open a charge account with a shipping company and enclose completed forms for the return shipment in the package with the painting.

Another way to show your art and sell it is at booth shows. These range from art fairs in the park sponsored by local clubs to highly commercialized juried expositions at some distance from home. A booth show is different from an exhibit in that the artist is present while the show is going on, usually over a weekend or longer. The exhibitor brings a body of work to the show and assembles a personal exhibit in an assigned space. Sometimes pegboard "walls" are provided by the show's sponsors, but more often the exhibitor must bring some sort of framework on which to hang up paintings. If the show is indoors, it's a good idea to bring lights and materials to decorate the space— to create an appealing showplace for your work. If the show is outdoors, lighting is unnecessary unless the showing continues into the evening, but some protection from the weather is advisable.

Booth shows are often a beginning artist's introduction to exhibiting and tend to begin with the

fairly informal, unjuried, outdoor show sponsored by a local club. As with many of the conditions under which beginning artists labor, such shows may often be the most grueling. In addition to difficulties due to inexperience and making do with makeshift exhibit equipment, violent weather and meager sales may cause initial discouragement. On the other hand, balmy weather and brisk, interested customer traffic can permanently "hook" the artist on booth shows.

Two great advantages to booth shows are the direct contact with the buying (or browsing) public and the opportunity for feedback on your work from ordinary people rather than artists. Such a show also provides an opportunity to compare your work and price structure with those of other participating artists, and learn from the more experienced ones some of the tricks of efficient setting up and arrangement of the exhibit space. While it is a great deal of work to mount a booth exhibit and act as your own salesperson, you also have the benefit of almost all the money from sales (minus expenses and entry fees, if any), whereas sales by galleries involve a commission of up to 50 percent of the retail price. Gallery representatives sometimes browse at booth shows, looking for new talent, but the frequency of important discoveries at art fairs seems to be equivalent to that of great movie stars being discovered in Hollywood drugstores.

Most of the time artists get their work into galleries by approaching them, rather than the other way around. It is a good idea to scout galleries before making a purposeful contact, checking whether your style of work and general level of expertise are compatible with other work shown. You may choose to introduce yourself and have some photographs available (slides are rather cumbersome for the casual approach) in case the gallery rep is receptive. Alternatively, you may send a letter of self-introduction with a vita or biographical sketch outlining your experience and awards, along with a clear vinyl slide page of slides. This mailing could be followed up with a phone call if no response is received within two weeks. Best of all is to have a contact made on your behalf by someone with connections in the gallery world—for example, by the director of a gallery in another town where you already show work.

The usual gallery commission of 40 to 50 percent may seem exorbitant to a newcomer to the field, but because gallery clientele tend to be upscale in their tastes, an expensive decor and ambience must be maintained, and gallery rents are usually very high because their locations tend to be in the expensive quarters of towns. Galleries often fail, because becoming established and financially secure is nearly as difficult for them as it is for artists.

Most galleries expect artists to leave their work on consignment, which means you will be paid for it only if it sells. Obviously this entails a measure of trust, and it is worthwhile to check out a prospective gallery with some of the artists who show there, or, if possible, with some who *used to* show there. Some galleries offer a contract specifying the terms of the relationship, but I have found that in the absence of real trust on both sides, contracts are almost worthless. This is especially true for unknown artists, for whom the sums of money involved in any breach of trust are too small to justify legal action. Emerging artists tend to be somewhat at the mercy of galleries, because they need the gallery more than the gallery needs them; there are more artists than there is gallery space. This imbalance in the relationship may require you to swallow your pride and strive to be accommodating. On the other hand, if agreements are broken, payments are withheld, or work "disappears," the relationship is best ended.

A good relationship with a gallery is a pearl beyond price and is worth considerable flexibility and effort to maintain. I've noticed that if the gallery personnel don't like an artist or an artist's work, it simply does not sell well. If, on the other hand, there is mutual trust and admiration, a gallery can help significantly to launch an emerging artist on a successful career by making enthusiastic sales efforts, hanging the work in advantageous locations in the gallery, advertising the work, and arranging special shows or features.

CONCLUSION

Throughout this book, my goal has been to share with you all the useful information I could assemble about transparent painting techniques and related practical matters. I have carefully refrained from making pronouncements about the nature of art, the good, the true, and the beautiful. That is for you to discover, and no one can do it for you.

There is no shortcut to becoming an artist; it is just a matter of doing it—and doing it, and doing it. But I hope that this book points the way toward some shortcuts in the practical and technical aspects of making works of art.

Here I would like to repeat the words from the Dalai Lama that opened this book (from *Ocean of Wisdom*, published by Clear Light Publishers, Santa Fe, N.M., 1989, and quoted here by permission):

> *Now if these words are helpful for you,*
> *then put them into practice.*
> *But if they aren't helpful,*
> *then there's no need for them.*

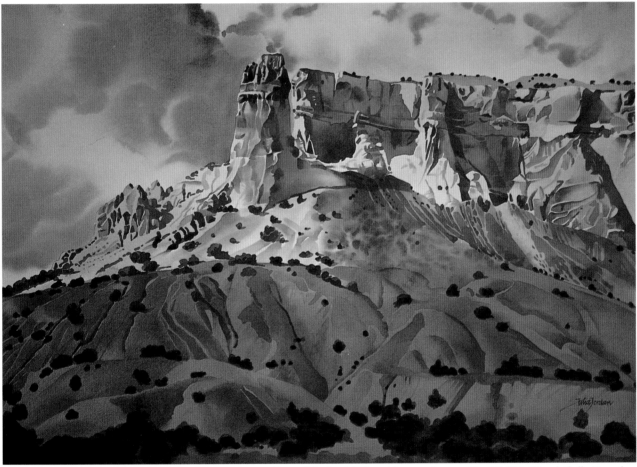

Partly Cloudy, Ghost Ranch by Julia Jordan. Transparent acrylic on d'Arches 140 lb. cold-pressed paper, 22 × 30" (56 × 76 cm). Collection of Linda and George Crawford.

LIST OF SUPPLIERS

When I first began to paint, my only supplier was the college bookstore. If something wasn't there, I didn't use it. Later I found that by making friends with my local art supply store, I could often get not only a wider spectrum of materials and supplies, but also advice on which ones were appropriate for accomplishing my artistic aims for a given project. If your local suppliers don't stock something you need, they will often order it specially for you.

Wandering through a well-stocked art supply store can be a delicious experience for an artist. The smorgasbord of materials and new products available may stimulate new ideas for self-expression and artistic experimentation.

MAIL-ORDER CATALOGS

If you don't have access to a well-supplied retail outlet, or if you know precisely what materials you need and there is no time to shop, mail-order art suppliers can be very helpful and are sometimes quite economical to use.

Below are listed the names and addresses of some mail-order suppliers I know of that stock my favorite materials and supplies. There are doubtless many more that would also serve your needs quite well.

Artisan/Santa Fe, Inc.
717 Canyon Road
Santa Fe, NM 87501
800-331-6375

Daniel Smith
4130 First Avenue South
Seattle, WA 98134-2302
800-426-6740

Dick Blick
PO Box 1267
Galesburg, IL 61401
800-447-8192

Napa Valley Art Store
1041 Lincoln Ave.
Napa, CA 94558
800-648-6696

New York Central Art Supply
62 Third Ave.
New York, NY 10003
800-950-6111

You may call the toll-free numbers and request a catalog, or directly order any items you wish.

SUPPLIES AND THEIR SOURCES

Throughout this book I have referred to various art supplies. Here is a list of those that you may have trouble finding.

Big Daddy brush	Napa Valley Art Store
Bogen tripod and projector platform	Bogen Photo Corp. 565 E. Crescent Ave. P.O. Box 506 Ramsey, NJ 07446 801-818-9500 (Inquire for local outlet.)
C & H mat cutter	United Mfrs. Supplies, Inc. 80 Gordon Dr. Syosset, NY 11791 800-645-7260
Fletcher Frame-Master framing tool	Dick Blick
Glass Skin	Airfloat Systems, Inc. 110 Elizabeth St. P.O. Box 229 Tupelo, MS 38802 800-445-2580
Golden acrylic paints and mediums	Daniel Smith and Artisan/Santa Fe
Mat board	More economical and less danger of shipping damage if purchased locally.
Mini Cine Cineflex rear projection screen: 20 × 20" (51 × 51 cm), 30 × 30" (76 × 76 cm) or 40 × 40" (102 × 102 cm)	Draper Screen Company 411 S. Pearl Spiceland, IN 47385 317-987-7999 (Inquire for local outlet.)
Painter's Pal palette and accessories	Dick Blick
Strongbox	Airfloat Systems, Inc. 110 Elizabeth St. P.O. Box 229 Tupelo, MS 38802 800-445-2580
Tri-hue color keys	Richard Nelson P.O. Box 481 Kula, Maui, HI 96790 808-878-1576
Zipp Clamp stretchers	Dick Blick

INDEX